Edited by Judith Collins
and Elsbeth Lindner

Writing on the Wall

Women Writers on Women Artists

WEIDENFELD & NICOLSON, LONDON

Grateful acknowledgement is made to the artists, owners, copyright holders and estates of the paintings reproduced. *The Corridor* 1950 by Maria Vieira da Silva © ADAGP, Paris and DACS, London 1993. *Flower Table* is reproduced by permission of the estate of Winifred Nicholson, copyright holder.

First published in 1993 by Weidenfeld & Nicolson, a division of the Orion Publishing Group Limited, Orion House, 5 Upper Saint Martin's Lane, London WC2H 9EA

A catalogue record for this book is available from the British Library.

ISBN 0 297 81369 2

Filmset by Selwood Systems, Midsomer Norton
Printed in Great Britain by Butler & Tanner Ltd, Frome and London

The editors would like to thank Fiona Robertson and Louisa Buck for their help in putting this project together.

Cover illustration by Maggi Hambling

Writing on the Wall

Contents

Preface

In the late spring of 1992 we began to discuss the idea of a book in which twenty women writers would write about their favourite work of art by a female artist in the Tate Gallery. There are some one thousand works in the gallery's possession, representing two hundred and twenty-eight artists, from Eileen Agar to Laetitia Yhap. The authors were given the widest possible brief – a literary response of any kind, whether story, reverie, poem or essay, of approximately two thousand words.

The idea ignited excitement in nearly all the writers we approached, and many knew instantly which work they would pick. Some had too many commitments to allow them to take part; those who did entered into the spirit of the enterprise with enthusiasm and great imagination, as the ensuing pages reveal. Women's creativity, both visual and literary, is celebrated here in splendid diversity.

The exhibition of *Writing on the Wall* which will open at the Tate Gallery to tie in with publication will allow everyone to discover their own responses to these works of art. But for those who will not be able to visit, and after the exhibition is over, the book will remain a fascinating marriage of two art forms. It has been a pleasure to bring the partners together.

Judith Collins and Elsbeth Lindner

Beryl Bainbridge

*The Remnants of
an Army* (1879)

by
ELIZABETH THOMPSON
(LADY BUTLER)

The spine of a book with a woman's name printed beneath the title informs the reader that the author is other than a man. If we are young this may not matter so much, but it is my belief that those of us who belong to an earlier generation will instantly become burdened with preconceived notions. Our minds are nothing if not visual; inextricably mingled with the printed text will surely flicker a picture of a female and in the background the blurred sexual baggage attached to such an image – lost love, babies, roses round the cottage door.

It is different with paintings. Enter a gallery and there, hanging on a wall, is a landscape, a portrait, a still life. Long before we have had time to identify the signature of the artist, the eye has registered shapes and colours. This happened to me when I first saw a painting by Elizabeth Thompson, or rather a reproduction on a postcard of *The Return from Inkerman*, painted in 1877, the year she married Major William Butler who fought in the Crimean War, became a general and was later knighted.

The painting, oil on canvas, depicts the remnants of the Guards, the 20th Division and odds and ends of infantry returning from the battle. Extremely realistic and superbly grouped, with a horseman off centre and a flock of birds rising into the colourless air, it has none of the static quality of a photograph. If anything, the ranks of men, some walking proudly, some sagging to the ground, are as full of movement as the chorus line in a ballet.

The postcard was sent me by an uncle, later imprisoned in one of the Japanese hell camps, and posted shortly before I succumbed to double pneumonia. I don't remember the details of that life-threatening disease, sufficient to say that I was shoved under the dining-room table during the May blitz and was saved at the eleventh hour by the administration of a miraculous new drug labelled M and B.

Convalescing in the upstairs bedroom I shook my head at offerings of black-market chocolate and fruit and begged instead for a piece of string, which, once handed over, I tied to one stiff corner of the pink satin eiderdown of the sick-bed. Then, propped up on pillows and tugging on it as though I held a pair of reins, I galloped my way to recovery.

Two years later, leafing through some volume on the market stall of a second-hand bookshop in Southport, I came across a reproduction of another picture painted by the same artist. At the time I don't think I realised it was the work of Elizabeth Thompson. I fancy I had an idea that

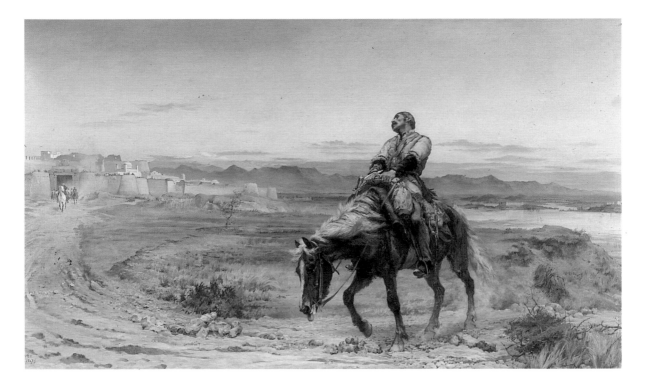

paintings just happened, in much the same way that for decades I believed Proust, Zola and Stendhal – indeed, anyone foreign – wrote in English. At any rate, having just bought for twopence an edition of the poems of Sir Walter Scott, I made a crude copy of *The Remnants of an Army*. Once home, I decided it was not enough to look at a picture. The way I saw it, if one liked a painting one should live it; enter into the frame, so to speak. I hadn't a room of my own but there was a box room in which, in battered suitcases, my father kept his commercial traveller's samples and business papers and where my mother stored her dahlia tubers in the humpbacked trunk she had once needed when sailing to and from her convent finishing school in Belgium.

By balancing a suitcase sideways across the humped back, so that it teetered from side to side, and attaching string to the handle at the front of the trunk, I soon found I could sway my way to Jellalabad on a dying nag. I spent hours reaching safety. No matter that outside, caught in wind and rain, the sycamore tree dashed its branches against the glass. For me, the merciless sun beat down and I coughed from the dust that rose from my horse's hooves. We had a dog called Pedro who used to sit beside me and howl. I kept trying to get rid of him because he wasn't in the picture. My mother was alarmed; anxiously she crept up and down the stairs to observe me rocking round the clock, but of the two the dog was more able to vocalise his concern.

Since that time I've read much about Elizabeth Thompson. *The Remnants of an Army*, although not on view there, is in the collection of the Tate Gallery, and she herself thought it one of her best works. For that reason it's my favourite; one should always trust the artist. Who else is in a position to judge what was being attempted and how close achievement came?

The army in question, which for obvious reasons does not feature in the picture, was the British one engaged in the Afghan War of 1838–42, allegedly fought to check Russian infiltration. On 13 January, a week after our forces had begun their disastrous retreat from Kabul, a sole survivor, Dr Brydone, arrived at Jellalabad.

A contemporary report written in suitably purple prose reads as follows: 'A sentry on the ramparts, looking out towards the Kabul road, saw a solitary white-faced horseman struggling on towards the fort. The word was passed; the tidings spread. Presently the ramparts were lined with officers,

looking out with throbbing hearts through unsteady telescopes. Slowly and painfully, as though horse and rider both were in an extremity of mortal weakness, the solitary, mounted man came tottering on. They saw he was an Englishman. On a wretched, weary pony, clinging as one sick or wounded to its neck he sat, or rather leaned forward ... a shudder ran through the garrison. That solitary horseman looked like the messenger of death. Few doubted that he was the bearer of intelligence that would fill their souls with horror and despair.'

Quite so! Carried half dead into the fort – the unfortunate pony went all the way and expired at the gate – Dr Brydone murmured that it was his belief he was the sole survivor of some 16,000 men.

In the painting the doctor is seated upright. This is possibly because the horse's neck is bent so low that were he to slump forward as reported he would be in danger of sliding to the ground. I like the way sky and landscape merge, and the way the meandering stagger of the wretched beast echoes the curve of the dusty track to safety. It may be less immediately dramatic than some of her other canvases, but its mood is faultless.

Elizabeth Thompson was born at Lausanne in 1846. Her father was a 'man of letters' and as a child she knew Charles Dickens. Her sister later became famous as Alice Meynell and she and Elizabeth travelled all over Europe with their father and were educated by him. I like to think it was he who encouraged Elizabeth, aged ten at the time of the Crimean War, to read in *The Times* the contemporary accounts of the battles of Balaclava and Inkerman by the war correspondent William Russell, thus steering her towards a life-long obsession with military subjects.

In 1870, along with her mother and Alice, she converted to Roman Catholicism, and the first picture she submitted to the Royal Academy was called *The Magnificat*. Fortunately it was turned down, possibly because it did not have any horses in it. In 1873 her painting *Missing*, an imaginary scene after the battle of the Franco-Prussian War was accepted, but hung so high up on the Academy walls as to be virtually lost from view. A year later she hit the jackpot with *The Roll Call*, a canvas depicting the survivors of a Crimean battle. The painting had originally been commissioned by a Mr Galloway, an industrialist from Knutsford, but so great was its popularity that the Prince of Wales wanted it. Mr Galloway said no, but then Queen Victoria asked to buy it, and how could Mr Galloway refuse? It was even

taken to the bedside of Florence Nightingale who had expressed a wish to see it.

I feel sorry for Elizabeth after this, because nothing could ever quite match that first national success. For another twenty years she went on being famous and lauded and all that, but the First World War was just round the corner, and when that was over the world was never quite the same. Before 1914 it was easy to believe in patriotism, in the glory of dying for one's country and the greatest empire on earth. Four years later, the senseless slaughter of young men and the recognised ineptitude of elderly generals had quenched for ever the idea of noble sacrifice. In 1924 the Academy rejected her submitted painting. She died as late as 1933, and modern critics of her work have unfairly branded her as someone who 'helped provide the popular support for the imperial adventures of the military heroes of the Victorian age.'

What rubbish! It may be that she echoed something which later political historians, who couldn't sketch a daffodil if their lives depended on it, interpreted as a mood of the times, but she can hardly be blamed for that. She was not a jingoist, but simply someone who could wield a brush and whose childhood imagination had been fired by war. Also, she was jolly near perfect at painting gun-smoke and horses.

The Dance (1988)

by
PAULA REGO

Jennifer was a mordant child. Her first memories were of biting and gnawing. Her teeth came unexpectedly early, 'before even the first snowdrops' said her mother, who was romantically inclined but passed her days fashioning loaves in the form of lobsters, crabs and indeterminate sea creatures armoured with crisp antennae. The broken antennae were kept for Jennifer and these were the secret of her precocious mandibles.

They lived above the bread shop; the house was thin and old and the windows looked out on the heaving grey North Sea. On winter afternoons, when sky and sea merged and the rain beat down on Cromer, her mother would draw the curtains and shiver. Then she would talk of another sea, peacock blue and peacock green, lapping white sands. A castle overlooked that sea, a castle alone on its promontory; no town, no bread shop. There she had lived, there still her mother lived. One day she would go there with Jennifer. 'You will see the sun as you have never seen it,' she said in her oddly formal English.

Once on the promenade, staring at the whitening sea, she wept, but went on staring at it. The rain slashed down and mixed with her tears. Jennifer began to cry too. 'In my beginning is my end,' said her mother. Jennifer pulled her sleeve with numb starfish fingers and they trudged up the cliff path. The house seemed warm to Jennifer, then, and welcoming, with the scent of the bread which was always baking, or steaming and brown on racks, and her father in his white overall waving through the misted pane in the kitchen door. But her mother would pull her coat collar up as if she were even colder now she was indoors, and she ducked her head down and ran up the stairs with her nose wrinkled. There was no escape from the doughy fragrance. On the sitting-room table, heaped on her mother's great Portuguese platter, azure and white as her far seas, were the day's failures or unsuccesses. 'There is no such thing as failure. There is only unsuccess,' said her father. Jennifer found this statement meaningless, but could see that it annoyed her mother. Anyhow, there they were for her tea-time delectation, broken bread lobster pincers, and crab claws, antennae and small warped crustaceans, and for her this was home, the smell of the bread and the crunch of the crust, the coal fire sizzling as the rain spat down the chimney, the curtains drawn and outside the great roaring sea and the lowering sky. And her mother was happy when she could not see the sea.

Later in life she could remember no summer on that northern coast, but

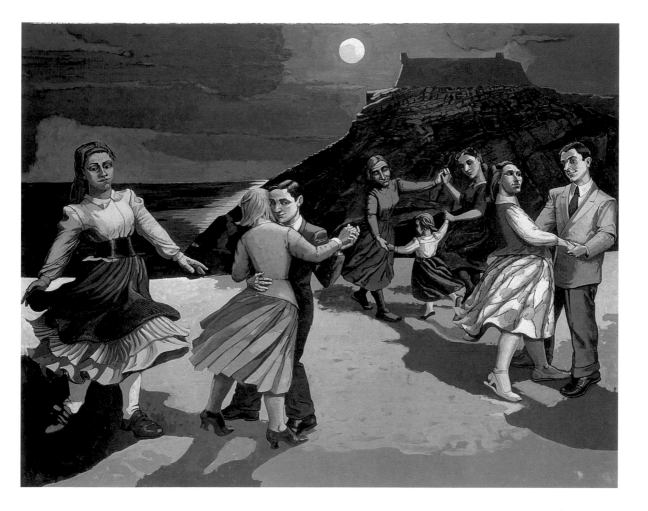

summer must have come and gone, five times in fact, when her mother took her to Portugal. They had to fly there and then travel a whole day in a bus. Jennifer was sick a number of times, but because of her mother's excitement she was able to rise above her lurching entrails and the awful quivering, quenching heat. 'Rise above it.' She had heard her father shout this at her mother when she herself was tucked up in bed, had been asleep even in the warm alcove by the chimney breast above the oven. In the darkness she imagined her mother floating and lost as a seagull over the icy whelm of ocean and she clenched her fists tight and prayed for her, as if she were one of the lifeboatmen or fishermen, who went in peril on the sea.

Now the bus was bumping off the white dusty track into a village square; her mother had seized both her limp hands and was squeezing them and staring into her face with wild shining eyes. 'I am happy. I am so happy,' she whispered. They hugged each other. Jennifer was glad for her, but most of all she was glad to clamber off the bus and stand unsteadily in the shade, while a great shrieking gaggle of women in black flapping clothes embraced her mother and wept and embraced her again. Then they were swooping down on Jennifer. 'Ah, the little beautiful.' 'Ah, it is at last Ginevra.' The tree's low branches trembled and its leaves which were like hands waved and fanned the hot air. Fat little purple fruits plopped through them and burst in carnal crimson against the ground. The aunts trampled over them. Seeds spurted and stuck to their heavy black shoes.

The castle stood on a headland up a long hill from the village; you could not see it until you were almost there. Parts of it resembled the massive fortresses Jennifer had seen in picture books; elsewhere it was dazzling white, like some of the houses in the village. There were arcades and galleries, courtyards and fountains. Most of the fountains didn't work. Lizards basked in the stone basins and thin cats pounced and played among the fallen leaves which choked them. Jennifer lay in a canopied swing in her grandmother's special courtyard, high above a little bay and the sea which was so bright she could not look straight at it. Here water played gently from an upturned urn on to a splashing cherub and behind her she could hear women's voices, a continuing murmurousness from upstairs windows, half shuttered now against the morning light. That was what they did all day, her mother, her grandmother, her aunts. They talked and they

sipped iced tea and they laughed in that shadowed room as they sat over their embroidery. Aunt Rosa was going to have a baby, perhaps tomorrow, perhaps this very day, who knew? Each evening Uncle Adriano came back from his work in his pale, crumpled suit, looking excited, and they would all smile and shake their heads. Her grandmother said, 'A baby chooses his own time. Is that not so, Ginevra?'

Jennifer had no idea how babies made their plans, but she nodded fervently, for her grandmother was the wise person, the queen of the castle; even though she was smaller than any of them and wore very plain clothes. There were a number of other older people about, mostly her grandmother's sisters or sisters-in-law. They were all widows and they looked frightening when they sat out together on the courtyard terrace, a flock of birds of anguish, although they smiled at her and stroked her hair as she sidled past. The only young aunt was Aunt Jezebel who was eighteen. Her name wasn't really Jezebel but this was how it sounded to Jennifer. Jezebel spent all day with the other women in the cool upstairs chambers or on the terrace, but she was not paying attention to them. Her round dreamy eyes stared out over the ramparts, her heavy brows contracted and her mouth turned down. She did not want to be there; not one bit. She shredded eucalyptus leaves and ground them under her heel; she moved about in an aura of camphor. This gave Jennifer a pang of wintry longing, for it reminded her of having colds in Cromer. She thought she liked Portugal, but it was very bright and it wasn't home. Soon her father was coming, and she looked forward to that, although she had the feeling that her mother did not. She had heard her mother referring to Cromer as Cromer Sur Mer and there was something not quite right about this.

Jezebel took Jennifer to the village to meet her father off the bus. They rode down the hill on Jezebel's bicycle, with Jennifer sitting in a pannier on the back. Jezebel was happy; she sang loud melancholy songs as they went, trailing her foot round the bends instead of braking, so that the dust blew up into their faces. In the square she left Jennifer at a table under the fig trees and disappeared into the bar. By the time the bus at last came throbbing in, Jennifer was feeling very hot and very embarrassed. She did not like to sit all alone as though she were a friendless orphan; people stared at her and some children came up and spoke to her but she could not answer them and after a little they ran off, looking back at her and

11

giggling. She chewed at her fingers and she bit her nails and she studied the ground beneath the table.

Suddenly Jezebel was leaning over her, lifting her up, pretending to be a loving aunt, and there was her father and there was a woman walking beside her father; he did not look well. His eyes glittered but his face was white. The woman was jauntily swinging a bottle by its neck. When she saw Jennifer looking at it, she stuffed it into her handbag. Her cheeks were puffy and pallid like fermenting dough; her bobbed blond hair was streaked with damp. There were subdued hugs and handshakes. Jennifer's father said the woman's name was Amicia; they were fellow travellers. He laughed after he said this, but no one else did. Jezebel had stopped looking happy and was glaring at Amicia. 'Well, I guess I'll love you and leave you,' she announced. 'See you later alligators,' she added over her shoulder. They watched in silence as her high heels wobbled across the square to the pale green portico of the little hotel. A group of men had emerged from the bar and were watching her too. A cat with a lizard protruding from its jaws slunk round the wall of the well, snarling to itself. It looked as if it were smoking a cigar. Jennifer longed to be back in Cromer.

At lunch, in the shuttered upper room, her longing increased. Her father had been odd and quiet in the taxi from the village. 'Not feeling too good; it's the heat,' he said, sighing and mopping his forehead. He had to borrow clothes from Adriano; his own were far too heavy. There wasn't much conversation. Usually the women spoke simultaneously and incessantly, sometimes in English, more often in Portuguese, even at times in French, for one of the great aunts came from Normandy. Although her mother had seemed pleased when he arrived, now, sitting next to him at the long table, she turned the other way, towards her own mother, and engaged in a discussion of embroidery silks suitable for the dress she was making for Rosa's baby. Nor was her father enjoying his plate of salt cod. He was pushing it around, nonplussed, trying to hide the glimmering and rigid fish tails under his potatoes. From high above the Virgin Mary eyed him with displeasure.

Things seemed better the next day. Colour returned to her father's face and although the sun shone bright as ever a breeze diffused the heat. In the evening there was a party in the village square. The tables were laid out in the open and everyone danced, even the old people. In one corner bumper

12

cars were flashing and colliding, and merry-go-round horses rose and sank and rose. The air boomed with different kinds of music and was hazy with smoke from the spits of tragic roasting piglets. Candles and bottles shone on the white tablecloths. Amicia appeared, weaving through the dancers, and joined them. She wore scarlet lipstick and she had an orange flower in her hair. She was drinking out of her own bottle, not very carefully. Pungent amber drops trickled down her chin and on to her throat. She flicked them away with a faintly grubby hand, shook her blond hair about and pulled off her jacket. The ancient aunts sighed and looked away from her. They had smiled at her and inclined their heads. They would not do this again. At the far end of the table Grandmama's face was expressionless. Only Jezebel stared unwinkingly at those twin rotundities which heaved and quivered beyond the merest strand of black and yellow dotted nylon. Only Jezebel and the men. The men who came swarming, touching Amicia's bare arm, entreating her to dance, pulling at her hands. They surrounded her, black as flies in their shiny suits. As Jennifer and her family left the square they could see her spinning about, still clutching her bottle, while the men formed a circle round her, clapping slowly, a measured clap like the beat of a funeral drum.

The old aunts went home then, but Grandmama led the rest of them down the cliff path to her terrace, a vast ledge overhanging the bay. The tide was full and tranced in the moonlight, almost inaudibly lapping and swelling far below. A surprise awaited them, a table laid out with plates of lobsters and salads, apricots and wine and iced lemonade. Adriano had brought his wind-up gramophone and for a while they sat and watched the sea and the moving heavens, and listened to a woman's voice in lamentation. 'Remember me. Remember me,' she pleaded, and Jennifer saw that the clouds and the moon were still and the whole night silenced, attentive only to that desperate cry. Then Jezebel was on her feet, changing the record, winding. 'We will dance,' she declared. She stretched out her hands to Jennifer's father, but he shook his head and sat back with his shy smile, clasping his glass of wine. Jezebel revolved slowly, furling and whirling her petticoats. staring now at the sea, now at the dark hillside, half angry, half yearning. Jennifer's mother pulled her and Grandmama up. They danced in a circle; their linked hands formed a grave and tender coronal of love. Jennifer forgot everything but this place, wished only to be here for ever.

Rosa and Adriano were dancing too, very slowly; she could see that Adriano was afraid of colliding with Rosa's huge stomach. Rosa rocked from side to side and Adriano held her at arm's length as though she were some unmanageable agricultural implement. Their shadows all mingled, separated, flowed, pacific as clouds.

And then there were other shadows, an alien blot which spread into the centre of the terrace. Amicia was there, and she was wrapped about a man. At least she had her jacket on again. But the man was Jennifer's father. She saw Amicia's face sagged against his, her red mouth smudging his collar. She saw Adriano gaze wistfully at them and Aunt Rosa looking savagely at Adriano. For a moment as they whirled round she saw her father as she had never seen him, a small man, sly, afraid and greedy. Then the music stopped, the dance was over. Amicia lurched to the table. The feral cats were scrabbling among the lobsters. 'Fucking bloody cats,' she yelled. 'Disgusting. Where's the music?' No one answered. They all stood still. She saw the gramophone. 'Aw, for Godsake. Come on then, I'll give you some music.' She grabbed a whole lobster and flung her jacket at the cats. Moving backwards she wrenched at the claws. The wilted orange flower fell out of her hair. She cradled the lobster to her bosom and began to sing, 'I can can and you can can, I can can ...' She kicked her legs up in the air and fell over. The feral cats were on her. She struggled to her feet, kicked a cat and fell again. She rolled on her back, still singing, rolled on to her side and went over the edge.

'Time to go home,' said Grandmama. They cleared the table into baskets. Jennifer threw Amicia's flower into the sea. It looked quite pretty bobbing there. 'Remember me,' she thought. She would not. But she would remember the dance. She split a lobster pincer with one crack of her teeth and made her pledge.

Pat Barker

FOOTPRINTS IN THE SNOW

Bird, Dead Hen and Harbinger Bird IV
(1952, 1957 and 1960)
by
DAME ELISABETH FRINK

The line of eyebrow pencil reached the back of Val's knee, and stopped. 'Come on, this is the difficult bit,' Jenny said. 'Stop wriggling.'

Val froze, standing on the kitchen table with her skirt held up and her cami-knickers showing. Breathily absorbed, Jenny carried the line to the top of her leg.

Neither of them noticed Nick at first. Then: 'What do *you* want?' Val asked.

'I'm getting a glass of water. Auntie Madge said I could.'

Nick filled the glass to the brim, and sipped carefully, feeling them watching him, Val with her skirt down now and her hands on her hips. 'Take your time,' she said.

He emptied the water into the sink, and put the glass on to the draining board. 'Thought Yanks *bought* you stockings,' he said, and scampered past them, to avoid the flat of Jenny's hand.

Back upstairs, he got into bed. Normally he fought hard against going to bed, because he was afraid of the dream, he was afraid of meeting Mrs Murphy in his sleep, but tonight was different. Harris was coming for him. They were going to find the plane.

'What plane?' Hughes had said, as the three of them lingered at the quietest end of the pitch, their thighs mottled with cold. 'There isn't any plane.'

'There is,' Harris insisted. 'I saw it.'

'Then you should have told somebody,' Hughes said. 'Anyway, even if there was one they'll've found it by now.'

That was true, Nick thought. However fast you cycled to where a plane had come down you always found the area roped off, men in uniforms in charge, but he hadn't wanted to disagree with Harris. Nick had been sent to stay here, away from London, away from the bombs, and Harris was his first friend.

He got out of bed and went to the window, checked to see there was no light coming from the landing, then pulled back the blackout curtain. Snow covered the lawn. By day, you could see the snow was covered with birds' footprints, like the letters of a mysterious language, but now, in the moonlight, only his own footprints showed, going to the bird table and back again. He'd taken the scraps out after breakfast. Not many scraps these days, Auntie Madge said. These days you were supposed to feed people on

16

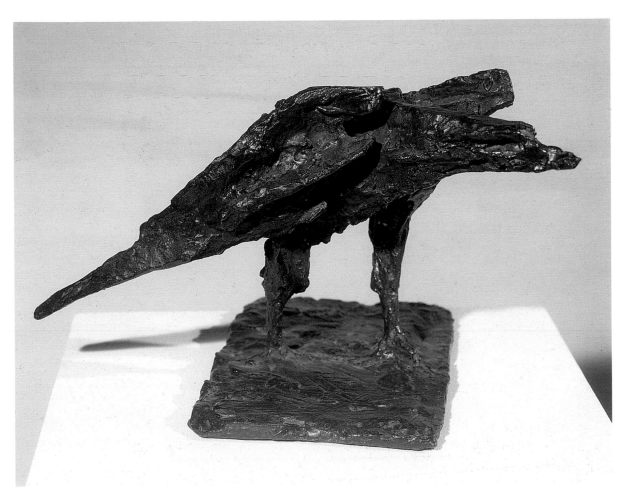

scraps. But there had been one stale crust, the orangey-brown scrapings from the bottom of the dripping jar, and a chicken carcase that had been boiled for broth. No meat left on it, but Auntie Madge said they might as well have it. He tramped down the lawn, the snow rising over the tops of his wellies, stinging the bare skin, and reached up to put the scraps on the table. Then he had stood, breath pluming from his open mouth, staring into the copse. He could see no birds, though as soon as he closed the kitchen door they were there, a robin, greenfinches, blue tits, great tits, all twittering and squabbling in a flurry of snow. Then, before his mind could find a word to name what he saw, a shadow of huge wings, a paleness of speckled breast, yellow feet reaching out, and, slowly, the great wings beat and beat again, as if trying to free themselves from something thicker than air, and the hawk rose up, a small, bright shape clasped negligently in one feathered claw.

He'd run into the kitchen to tell Auntie Madge. 'Sparrowhawk,' she said, turning back to the mixture she was beating in a bowl. 'Be after them chicken bones.'

But it was a tit he'd killed, and he hadn't looked like a creature who could ever miss.

The growl of a motorbike attracted his attention: Jake coming to collect Val. He ran out onto the landing and peered down through the bannisters. Jake, standing rather self-consciously in the hall, saw the movement and came halfway upstairs. Flakes of snow clung to the collar of his flying jacket. His skin was speckly and there were pale rings round his eyes where the goggles had been. 'Does your Auntie Madge know you're out of bed?' he asked. Without waiting for an answer, he put his hand between the bars of the bannisters, making it into an animal, and Nick squirmed and squealed, trying, and not trying, to get away.

Val came into the hall. 'What you doing out of bed? Go on, scarper.'

Ten minutes later Nick heard the motorbike start. He imagined Jake snapping the goggles into place, looking over his shoulder to check Val was safe. He saw her bare legs with their fake seams curve round his lean hips. They were going to a dance. So tonight he would be able to listen to the throb of bombers going out, and not have to keep his fingers crossed, and wish over and over again: not Jake, not Jake.

He heard the spray of gravel on the drive, thinking it would be awful if

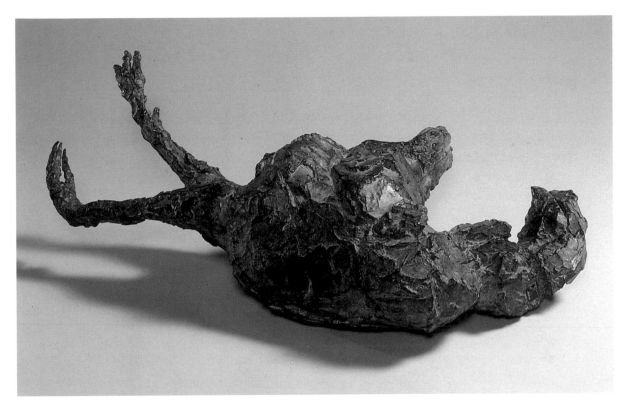

they met Harris, but then, suddenly, he knew Harris wouldn't come. It was all talk, they wouldn't do it, even the plan seemed childish, feeble, compared with the adult power of Jake, the smell of cold air on his speckled skin.

Nick touched the photograph of his Mum and Dad, then crossed his legs in a particular way, and folded his arms. If he did these things and got them exactly right, the dream didn't happen, he was safe from Mrs Murphy for another night. He screwed up his eyes against the encroaching shadows and told himself: sleep, sleep.

The rattle of gravel against his window woke him. He jumped out of bed, and ran to the window. A dark shape, in the middle of the lawn, standing at the end of a trail of footprints. Nick waved, then quickly dressed, pulling a thick jumper on over his pyjamas, then his school mackintosh, gloves, a red and white woollen hat.

He crept down through the sleeping house, past the ticking grandfather clock, jarred his knee against a chair and stealthily opened the back door and sidled out. And there was the snow, great drifts and billows of it, lit by a full moon, making ordinary shapes unfamiliar. He stepped into it, his wellies sending up little sprays on either side like the wash round a boat. He pressed his weight down hard, liking the way the snow squeaked. Harris had retreated to the shadow of the trees, and for a moment Nick feared he might not be there, that he had imagined the shape on the lawn, but then he saw Harris's pale, fat, owl-like face with the glasses glinting. They met, silently. Nick had hidden his bike behind the cowshed. From there it was a struggle across the field, through the gap in the hedge, and across the ditch into the lane.

A dusting of dry, soft snow; hard, impacted snow underneath. Even when they were away from the house and it was safe to speak, they didn't. There was no sound except for the whistling of their tyres in the snow. It reflected a bluish light into their faces. They followed the motorbike tracks as far as the crossroads, then went straight on when the tracks turned right. A few hundred yards further on they abandoned the bikes behind a hedge, and set off on foot across the fields to Hopper's wood.

The wood lay along the crest of a ridge, the bare trees grey like smoke. Nick was thinking there would be no plane and that it didn't matter, just being out at night in the snow was an adventure. He breathed deeply, and the cold burnt the inside of his nose.

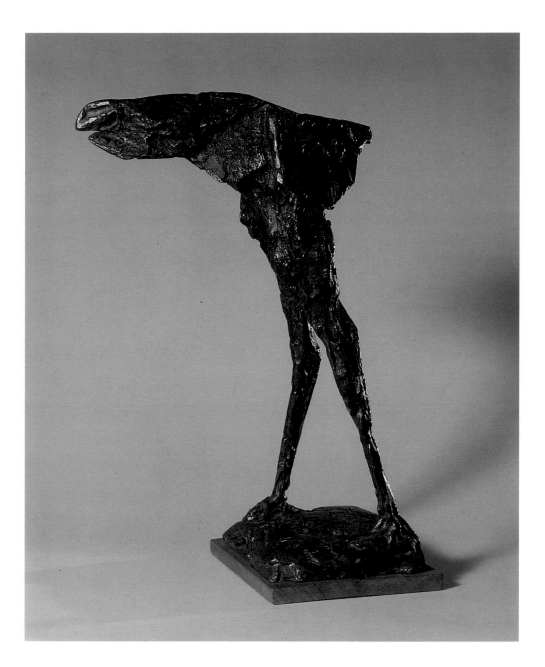

A barbed wire fence surrounded the wood. They had to wriggle through on their bellies, trying to avoid brambles and nettles, holding the barbs away from each other's struggling backs. The manoeuvring stopped them being nervous which otherwise they might have been, for the silence in the wood was different from the silence of garden and fields. Nick gestured to Harris to stop, and they listened and heard no sound except for the creak of branches under the weight of snow.

'Come on,' Harris said. Harris was podgy, he breathed through his nose, he seemed to have no cheekbones, and yet somehow the blue light coming off the snow had found them. *He believes in it*, Nick thought. *He really thinks he saw it.* And immediately he became nervous and excited.

But for a long time there was nothing. Then they began to see the early signs of an enormous disaster. A tree leaning against another tree, branches scattered in the snow, pale gold amputated surfaces exposed to the light. They reached the crest of the hill, and looked down the slope but, instead of the expected wreck, saw only a long black scar and the jagged shapes of burnt trees.

Harris set off down the slope. Nick followed, but more slowly. Once he slipped and landed painfully on his bottom. Harris was walking round the clearing by the time he got there. 'I saw it.' he said. 'I saw the flames.'

'Long time ago,' Nick said. There had been a crash here, no doubt about it, but all trace of the crashed plane had gone.

'Last night,' Harris insisted.

He sounded as if he might be going to blub. Nick turned away, giving him time to get over it. It was what everybody dreamt about, of course, and once, last year, it had happened. A plane had exploded in the air not far from the school, and boys, streaming across the fields, had got to the scattered wreckage before anybody else, and picked up bits of the fuselage, and sold them, for boiled sweets, cigarette cards, even money. Then the lockers had been searched, and a boy called Widgery, who sat at the back of the class and blinked a lot, got the cane in front of the whole school because, while everybody else had bits of the fuselage, Widgery had bits of the pilot.

The pilot. Nick looked round the circle of burnt trees. There must be a moment when you knew, he thought, when you were spinning out of control and the ground with its trees and houses, its little squares of fields

was rushing up towards you, and you knew you were not going to be able to pull out of it. He broke off part of a branch. It came away easily in his hand, crumbling like chalk, staining his fingers black. He lifted them to his nose, and smelled. Charcoal.

In London the bomb sites smelled of burnt brick. White dust from the wounded houses spread everywhere, crunching underfoot. On the morning after a raid people stood around the streets, pink-eyed, dazed-looking, glad to have survived. Children swarmed over the wrecked houses, shouted at by parents, by policemen, by air raid wardens, but always managing to get in.

He'd gone to Mrs Murphy's house the morning after the bomb fell. Ceilings bulged and sagged, glass glittered on the floor, his own face lurked in the depths of a mirror like a small pale fish in the depths of a dark pond. He pushed the door open, and walked into the bedroom. The whole room was full of feathers, feathers everywhere, lifting in the draught from the shattered window. He couldn't think where they came from, but then he saw the burst mattress, the split pillows, and in the centre of the pillow a place where the feathers didn't lift and drift and float because they were stuck to something that he must never let himself see.

He turned back to Harris, but Harris was sitting on a log, wrestling with his sense of loss.

She wouldn't go into the shelters with everybody else, they said. She was an old woman, Mrs Murphy, she didn't believe in banks, she didn't give two hoots for Hitler, and so she stayed by herself, with her savings in a steel box under the bed.

Nick stared blankly at the snow. He knew he mustn't let her back into his mind, and so he turned his thoughts deliberately to the hawk he'd seen that morning, the beak, the claws, the terrified silence of the other birds. He'd been upset by the tit's death. 'It's food, *stupid*.' Val had said, coming down to breakfast, late as usual. 'You wouldn't want the hawk to starve, would you?' Mrs Murphy's night dress had been rucked up over her belly, a rounded belly, like women had when they were going to have a baby, but she was too old for that. He'd gone down the garden afterwards to see, placing his feet exactly in the line of footprints he'd left earlier, not sure why this mattered, but knowing it did, and there, standing by the bird table in that immense silence, he'd seen the blue and green and yellow feathers scattered across the snow.

L'Infirmière (c 1914–18)

by
BEATRICE HOW

Beatrice How, who lived from 1867 to 1932, painted many pictures of children. She never married and had no children herself. Childhood forms the central theme of much of my fiction, although I have never had any children. Beatrice How's *L'Infirmière* shows an idealised portrait of a woman and child. The young nurse steals a voluptuous interlude with the passive and vulnerable object of desire, a beautiful baby with a sort of woodland innocence. His sticking-out feet with their pink bows are as tempting as sweets. In spite of the strong sensual element, the painting has been given a sacred context through the device of a homely dinner plate placed behind the baby's head to form a halo, so that the couple have become the mystical unit of Madonna and Child. I cannot tell if this is a sentimental touch or an ironic one and wonder if Beatrice How came to believe, as I have, that only for the childless does the ideal of maternity endure. Women without children envy the uncensored intimacy of the maternal union, the blameless access to beloved flesh. They do not have to come to terms with the isolation of mothers with small children, the loss of freedom. Childless women sometimes covet the offspring of others but rarely offer beleaguered mothers any help. Women without children sometimes steal babies – but they always give them back.

*

Women steal other people's husbands so why shouldn't they steal other people's babies? Mothers leave babies everywhere. They leave them with foreign students while they go out gallivanting, hand them over to strangers for years on end, who stuff them with dead languages and computer science. I knew a woman who left her baby on the bus. She was halfway down Grafton Street when she got this funny feeling and she said, 'Oh, my God, I've left my handbag,' and then with a surge of relief she felt the strap of her bag cutting into her wrist and remembered the baby.

I never wanted to steal another woman's husband. Whatever you might make of a man if you got him first hand, there's no doing anything once some other woman's been at him, started scraping off the first layer of paint

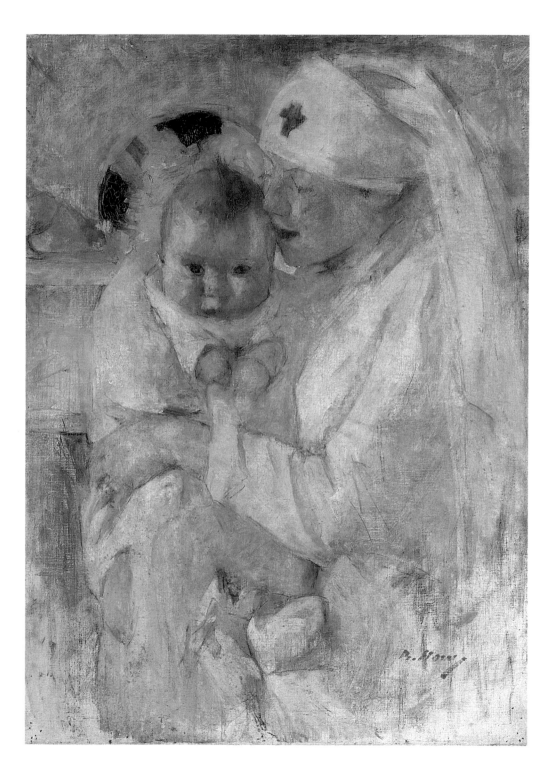

to see what's underneath, then decided she didn't like it, and left him like that all scratchy and patchy.

Babies come unpainted. They have their own smell, like new wood has. They've got no barriers. Mothers go at their offspring the way a man goes at a virgin, no shame or mercy. A woman once told me she used to bite her baby's bum when she changed its nappy. Other women have to stand back, but nature's nature.

Sometimes I dream of babies. Once there were two in a wooden cradle high up on a shelf. They had very small dark faces, like Russian icons, and I climbed on a chair to get at them. Then I saw their parents sitting up in bed, watching me. I have a dream about a little girl, three or four, who runs behind to catch up with me. She says nothing but her hand burrows into mine and her fingers tap on my palm. Now and then I have a baby in my sleep, although I don't remember anything about it. It's handed to me, and I know it's mine, and I just gaze into the opaque blueness of the eye that's like the sky, as if everything and nothing lies behind.

It comes over you like a craving. You stand beside a pram and stare the way a woman on a diet might stare at a bar of chocolate in a shop window. You can't say anything. It's taboo, like cannibalism. Your middle goes hollow and you walk away stiff-legged, as if you have to pee.

Or maybe you don't.

It happened just like that. I'd come out of the supermarket. There were three infants, left lying around in strollers. I stopped to put on my headscarf and I looked at the babies, the way people do. I don't know what did it to me, but I think it was the texture. There was this chrysalis look. I was wondering what they felt like. To tell the truth my mouth was watering just for a touch. Then one of them turned with jerky movements to look at me.

'Hello,' I said. She stirred in her blankets and blew a tiny bubble. She put out a toe to explore the air. She looked so new, so completely new, that I was mad to have her. It's like when you see some dress in a shop window and you have to have it because you think it will definitely change your life. Her skin was rose soft and I had a terrible urge to touch it. 'Plenty of time for that,' I thought as my foot kicked the brake of the pram.

Mothers don't count their blessings. They complain all the time and they resent women without children, as if they've got away with something. They see you as an alien species. Talk about a woman scorned! And it's not men

who scorn you. They simply don't notice you at all. It's other women who treat you like the cat daring to look at the king. They don't care for women like me, they don't trust us. Well, I don't like them much either.

I was at the bus stop one day and this woman came along with a toddler by the hand and a baby in a push-car. 'Terrible day!' I said. Well it was. Cats and dogs. She gave me a look as if she was about to ask for a search warrant and then turned away and commenced a performance of pulling up hoods and shoving on mittens. It wasn't the rain. She didn't even notice the rain, soaked to the bone, hair stuck to her head like a bag of worms. She had all this shopping, spilling out of plastic bags, and she bent down and began undoing her parcels, arranging them in the tray underneath the baby's seat, as if to say to me, 'This is our world. We don't need your sort.' Not that I need telling.

It was a relief when the bus came – but that was short-lived. I don't know why mothers can't be more organised. She hoisted the toddler on to the platform and then got up herself, leaving the baby all alone in the rain to register its despair. 'You've forgotten the baby,' I said, and she gave me a very dirty look. She lunged outward and seized the handles of the pram and tried to manhandle it up after her, but it was too heavy. Sullen as mud, she plunged back out into the rain. This time the toddler was abandoned on the bus and it opened its little mouth and set up a pitiful screeching. She unstrapped the baby and sort of flung it up on the bus. Everyone was looking. Back she clambered, leaned out again and wrestled the pram on board, as if some sort of battle to the death was involved. I don't think the woman was in her right mind. Of course, half the groceries fell out into the gutter and the baby followed. 'You're going about that all wrong,' I told her, but she took no notice. The driver then woke up and said he couldn't take her as there was already one push-car on the bus. Do you think she apologised for keeping everyone waiting? No! She merely gave me a most unpleasant glance, as if I was the one to blame.

Walking away from the supermarket with someone else's child, I didn't feel guilty. I was cleansed, absolved of the guilt of not fitting in. I loved that baby. I felt connected to her by all the parts that unglamorous single women aren't supposed to have. I believed we were allies. She seemed to understand that I needed her more than her mother did and I experienced a great well of pity for her helplessness. She could do nothing without me

and I would do anything in the world for her. I wheeled the pram out through the car park, not too quickly. Once I even stopped to settle her blankets. Oh, she was the sweetest thing. Several people smiled into the pram. When I gave her a little tickle, she laughed. I think I have a natural talent as a mother. I look at other women with their kids and think, 'She's doing that all wrong, she doesn't deserve to have her.' I notice things. The worst mothers are the ones with too many kids. Just like my mum. They bash them and yell at them and then they give them sweets. Just like this woman I saw watching me from the doorway of the supermarket. She seemed completely surrounded by children. There must have been seven of them. One kid was being belted by another and a third was scuttling off out under a car. And she just watched me intently with this pinched little face and I knew she was envying me my natural ease as a mother. I knew a widow once, used to leave her baby in the dog's basket with the dog when she went out to work.

And all this time, while I was pushing and plotting, where was her mother? She might have been in the newsagent's, flipping the pages of magazines, or giving herself a moustache of cappuccino in the coffee shop, or in the supermarket gazing at bloated purple figs and dreaming of a lover. Mothers, who swear that they would die in an instant for you, are never there when you need them. Luckily, there is frequently someone on hand, as for instance myself, who was now wheeling the poor little thing out of harm's way, and not, if you ask me, before time.

I can't remember ever being so happy. There was a sense of purpose, the feeling of being needed. And you'll laugh now, but for the first time in my life, looking into that sweet little face, I felt that I was understood.

When my mum died I got depressed and they sent me along to see a psychiatrist. He said to me, 'You're young. You have to make a life of your own.' I was furious. 'Hardly anyone makes a life of their own,' I told him. 'They get their lives made for them.' He asked me about my social life and I said I went to the pictures once in a while. 'You could put an advertisement in one of the personal columns,' he said.

'Advertisement for what?' I said.

'A companion,' he said.

'Just like that?' I must say I thought that was a good one. 'You put an

advertisement in the paper and you get a companion?' I pictured a fattish little girl of about ten with long plaits.

'People do,' he promised me. 'Or you could go to an introduction agency.'

'And what sort of thing would you say in this advertisement?'

'You could say you were an attractive women, early thirties, seeking kind gentleman friend, view to matrimony.'

I was so mad. I lashed out at him with my handbag. 'You said a companion. You never said anything about a gentleman friend.'

Well, I make out all right. I got a bit of part-time work and I took up a hobby. I became a shoplifter. Many people are compelled to do things that are outside their moral strictures in these straitened times, but personally I took to shoplifting like a duck to water. It gave me a lift and enabled me to sample a lot of interesting things. The trick is, you pay for the bulky items and put away the small ones, fork out for the sliced loaf, pinch the kiwi fruit, proffer for the potatoes, take the pâté, pay for the firelighters, stash the little tray of fillet steaks. In this way I added a lot of variety to my diet – lumpfish roe and anchovies and spiced olives and smoked salmon, although I also accumulated a lot of sliced bread. 'Use your imagination,' I told myself. 'There are other bulky items besides sliced loaves.'

Perhaps it was the pack of nappies in my trolley that did it. I hate waste. It also just happened that the first sympathetic face I saw that day (in years, in point of fact) was that tiny baby left outside in her pram to wave her toe around in the cold air, so I took her too.

I thought I'd call her Vera. It sounded like the name of a person who'd been around for a long time, or as if I'd called her after my mother. When I got home the first thing I did was to pick her up. Oh, she felt just lovely, like nothing at all. I went over to the mirror to see what kind of a pair we made. We looked a picture. She took years off my age.

Vera was looking around in a vaguely disgruntled way, as if she could smell burning. 'Milk,' I thought. 'She wants milk.' I kept her balanced on my arm while I warmed up some milk. It was a nice feeling, although inconvenient. I would have to get used to that. It was like smoking in the bath. I had to carry her back with the saucepan, and a spoon, and a dishtowel for a bib. Natural mothers don't have to ferret around with saucepans and spoons. They have everything to hand, inside their slip. I tried to feed her off a spoon but she blew at it instead of sucking. There

was milk in my hair and on my cardigan and quite a lot of it went on the sofa, which is a kingfisher pattern, blue on cream. After a while she pushed the cup away and her face folded up as if she was going to cry. 'Oh, sorry, sweetheart,' I said. 'Who's a stupid mummy?' She needed her nappy changed.

To tell the truth I had been looking forward to this. Women complain about the plain duties of motherhood but to me she was like a present that was waiting to be unwrapped. I carried her back downstairs and filled a basin with warm water and put a lot of towels over my arm. How did I manage this, you ask? Well, a trail of water from kitchen to sofa tells the tale – but I managed the talc and the nappies and a sponge and all the other bits and pieces. I was proud of myself. I almost wished there was someone there to see.

By now Vera was a bit uneasy (perhaps I should have played some music, like women do to babies in the womb, but I don't know much about music). I took off the little pink jacket, the pink romper suit that was like a hot water bottle cover and then started to unwrap the nappy. A jet of water shot up into my eye. I was startled and none too pleased. I rubbed my eye and began again, removing all that soggy padding. Then I slammed it shut. The child looked gratified and started to chortle. Incredulous, I peeled the swaddling back once more. My jaw hung off its hinges. Growing out of the bottom of its belly was a wicked little ruddy horn. I found myself looking at balls as big as pomegranates and when I could tear my eyes away from them I had to look into his eye, a man's eye, already calculating and bargaining.

It was a boy. Who the hell wants a boy?

'Hypocrite!' I said to him. 'Going round with that nice little face.'

Vera stuck out his lower lip.

Imagine the nerve of the mother, dressing him up in pink, palming him off as a girl! Imagine, I could still be taken in by a man.

Now the problem with helping yourself to things, as opposed to coming by them lawfully, is that you have no redress. You have to take what you get. On the other hand, as a general rule, this makes you less particular. I decided to play it cool. 'The thing is, Vera,' I told him (I would change his name later. The shock was too great to adjust all at once), 'I always thought of babies as female. It simply never occurred to me that they came in the potential rapist mode. Now, clearly there are points in your favour. You do

look very nice with all your clothes on. On the other hand, I can't take to your sort as a species.'

I was quite pleased with that. I thought it very moderate and rational. Vera was looking at me in the strangest way, with a sweet, intent, intelligent look. Clearly he was concentrating. There is something to be said for the intelligent male. Maybe he and I would get along. 'The keynote,' I told him, 'is compromise. We'll have to give each other plenty of space.' Vera smiled. He looked relieved. It was a weight off my mind too. Then I got this smell. It dawned on me with horror the reason for his concentration. 'No!' I moaned. 'My mother's Sanderson!' I swooped on him and swagged him without looking too closely. His blue eyes no longer seemed opaque and new but very old and angry. He opened his mouth and began to bawl. Have you ever known a man who could compromise?

All that afternoon I gazed in wonder on the child who had melted my innards and compelled me to crime. Within the space of half an hour he had been transformed. His face took on the scalded red of a baboon's behind and he bellowed like a bull. His eyes were brilliant chips of ice behind a wall of boiling water. I got the feeling it wasn't even personal. It was just what he did whenever he thought of it. I changed his nappy and bounced him on my knee until his brains must have scrambled. I tried making him a mush of bread and milk and sugar, which he scarcely touched, yet still managed to return in great quantity over my ear. With rattling hands I strapped him into the stroller and took him for a walk. Out of doors the noise became a metallic booming. People glared at me and moved away and crows fell off their perches in the trees. Everything seemed distorted by the sound. I felt quite mad with tiredness. My legs seemed to be melting and when I looked at the sky the clouds had a fizzing, dangerous look. I wanted to lie flat on the pavement. You can't when you're a mother. Your life's not your own any more. I realised now that the mother and child unit is not the one I imagined but a different kind in which she exists to keep him alive and he exists to keep her awake.

I hadn't had a cup of tea all day, or a pee. When I got home there was a note on the door. It was from my landlord, asking had I a child concealed on the premises. Concealment, I mirthlessly snorted, would be a fine thing. He said it was upsetting the other tenants and either it went or I did.

I crept in to turn on the news. By now Vera would be reported missing.

His distraught mother would come on the telly begging whoever had him to please let her have her baby back. It was difficult to hear above the infant shrieks but I could see Bill Clinton's flashing teeth and bodies in the streets in Bosnia and men in suits at EEC summits. I watched until the weatherman had been and gone. Vera and I wept in unison. Was this what they meant by bonding?

Sometime in the night the crying stopped. The crimson faded from my fledgling's cheek and he subsided into rosy sleep. There was a cessation in the hostile shouts and banging on walls from neighbours. I sat over him and stroked his little fluff of hair and his cheek that was like the inside of a flower and then I must have fallen asleep for I dreamed I was being ripped apart by slash hooks but I woke up and it was his barking cries slicing through the fibres of my nerves.

Vera beamed like a rose as I wheeled him back to the supermarket. Daylight lapped around me like a great, dangerous, glittering sea. After twenty-four hours of torture I had entered a twilight zone and was both light-headed and depressed so that tears slid down my face as I exulted at the endurance of the tiny creature in my custody, the dazzling scope of his language of demand which ranged from heart-rending mews to the kind of frenzied sawing sounds which might have emanated from the corpse stores of Dr Frankenstein, from strangled croaks to the foundation-rattling bellows of a Gargantua. He had broken me. My nerve was gone and even my bones felt loose. I had to concentrate, in the way a drunk does, on setting my feet one in front of the other. I parked him carefully outside the supermarket and even did some shopping, snivelling a bit as I tucked away a little tin of white crab meat for comfort. Then I was free. I urged my trembling limbs to haste. 'You've forgotten your baby!' a woman cried out. My boneless feet tried an ineffectual scarper and the wheels of the push-car squealed in their pursuant haste. Upset by the crisis, the baby began to yell.

There are women who abandon babies in phone booths and lavatories and on the steps of churches, but these are stealthy babies, silently complicit in their own desertion. Vera was like a burglar alarm in reverse. Wherever I set him down, he went off. I tried cafés, cinemas, police stations. Once, I placed him in a wastepaper basket and he seemed to like that, for there wasn't a peep, but then when I was scurrying off down the street, I remembered that vandals sometimes set fire to refuse bins, so I ran back

and fished him out. At the end of the day we went home and watched the news in tears. There was no report of a baby missing. Vera's cries seemed to have been slung like paint around the walls so that even in his rare sleeping moments they remained violent and vivid and neighbours still hammered on the walls. Everyone blamed me. It was like being harnessed to a madman. It reminded me of something I had read, how in Victorian almshouses, sane paupers were frequently chained to the bed with dangerous lunatics.

By the third day I could think of nothing but rest. Sleep became a lust, an addiction. I was weeping and twitching and creeping on hands and knees. I wanted to lie down somewhere dark and peaceful where the glaring cave of my baby's mouth could no more pierce me with its proclamations. Then, with relief, I remembered the river bed. No one would find me there. Feverishly I dressed the child and wheeled him to the bridge. We made our farewells and I was about to hop into oblivion when I noticed a glove, left on one of the spikes that ornament the metalwork, so that whoever had lost it would spot it right away. It was an inspiration, a sign from God. I lifted Vera on to the broad ledge of the bridge, hooked his little jumper on to a spike, and left him there, peering quite serenely into the water.

At the end of the bridge I turned and looked back. The baby had disappeared. Someone had taken him. It seemed eerily quiet without that little soul to puncture the ozone with his lungs. Then I realised just why it was so quiet. There wasn't a someone. There hadn't been anyone since I left him there.

I raced back. 'Vera!' There was no sound, and when I gazed into the water it offered back an ugly portrait of the sky.

'Vera!' I wailed.

After a few seconds the baby surfaced. At first he bounced into view and bobbed in the water, waiting to get waterlogged and go down again. Then he reached out an arm as if there was an object in the murky tide he wanted. He didn't seem frightened. There was something leisurely about that outstretched hand, the fingers slightly curled, like a woman reaching for a cake. He began to show signs of excitement. His little legs started to kick. Out went another arm towards an unseen goal. 'What are you doing?' I peered down into the filthy water in which no other living thing was. Up came the arm again, grabbed the water and withdrew. His feet kicked in

delight. The baby's whole body looked delighted. I moved along the wall, following his progress, trying to see what he saw, that made him rejoice. Then I realised; he was swimming. The day was still and there was very little current. He gained confidence with every stroke. 'Wait!' I kept pace along the wall. The baby took no notice. He had commenced his new life as a fish. 'Wait!' I cried. For me, I meant. I wanted to tell him he was wonderful, that I would forgive him all his smells and yowling for in that well defended casement was a creature capable of new beginnings. He did not strike out at the water as adults do but used his curled hands as scoops, his rounded body as a floating ball. He was merely walking on the water like Jesus, or crawling since he had not yet learned to walk. 'Wait!' I begged as he bobbed past once again. I threw off my raincoat and jumped into the water. As I stretched out to reach the little curving fingers, he began to snarl.

I would like to report a happy ending, but then too I have always hankered for a sighting of a hog upon the wing. It took five more days to locate the mother. She told the police she had had a lovely little holiday by the sea and thought their Clint was being safely looked after by a friend, who, like everyone else in her life, had let her down. As it transpired, I knew the mother and she knew me, although we did not refresh our acquaintance. It was the pinched little woman with all the kids who had watched me wheel her child away. She said their Clint was a bawler, she hadn't had a wink of sleep since the day he was born, but she would take him back if someone gave her a Walkman to shut out the noise. Nobody bothered about me, the heroine of the hour – a woman who had risked her life to save a drowning child. It was the mother who drew the limelight. She became a sort of cult figure for a while and mothers could be spotted everywhere smiling under earphones, just as they used to waddle about in tracksuits a year or two ago. It was left to us, the childless, to suffer the curdling howls of the nation's unattended innocents.

Some women don't deserve to have children.

Eleanor Bron

PROLONGING THE BRIEF –
A PARADOX

Long Meadow (1982)
by
RITA DONAGH

and

Winter Garden (*c* 1929–37)
by
EVELYN DUNBAR

Write about your favourite picture at the Tate by a woman. A straightforward enough brief, that turned out to be quite an adventure, the rewards not material but wrested from circumstance by unforeseeable discoveries. Slight embarrassment at not having a favourite picture at the Tate, as such – any one picture; and I could not remember any picture in particular as being by a woman. I must have seen some of Bridget Riley's work there at some time, shurely? Gwen John? Elisabeth Frink? Very few women artists at all sprang fully formed into my mind. But even those would come under 'admired', not favourite, in the way that Hobbema's famous avenue of trees is favourite, or Picasso's *Weeping Woman* (try not to think that he made her cry in the first place, the way some directors bully an actress to get the performance they want), or so many Rembrandts, or my friend Tony Day's flat fen landscapes full of peace, the only person whose paintings I have ever gone so far as to buy. This is discovery number one: I am not only ignorant in general about art, I am ignorant in particular about women's art.

A cycle ride to the Tate, an afternoon's browse from gallery to gallery, should remedy this lapse. I may not know much about it but I know what I like. My reflexes are swift, my reactions stick. It is true that I am hard of choosing the way some people are hard of hearing, but with luck that problem will take care of itself. I have a system for looking.

In the last few years I have learned two things about visiting art galleries. The first is that two hours is my absolute maximum. After that fatigue and thirst seize me, and visual indigestion. My lumbar region rebels and my mind spins. The second lesson followed on one of those horrid insights that sometimes plague me: looking at pictures in art galleries is as absurd as looking at animals in a zoo. This was a shock – I happen to love doing both. Zoos are self-evidently unnatural. I don't know why it took me so long to realise that art galleries are, too. And yet, apart from ecclesiastical and municipal commissions, it's only recently that artists and sculptors have been commissioned to produce work whose sheer scale clamours to be shown first and foremost, if not exclusively, in galleries. A far cry from house and hearth. An awful lot of paintings are better looked at one by one and not side by side.

I have learned to combat this new knowledge with my system, which is

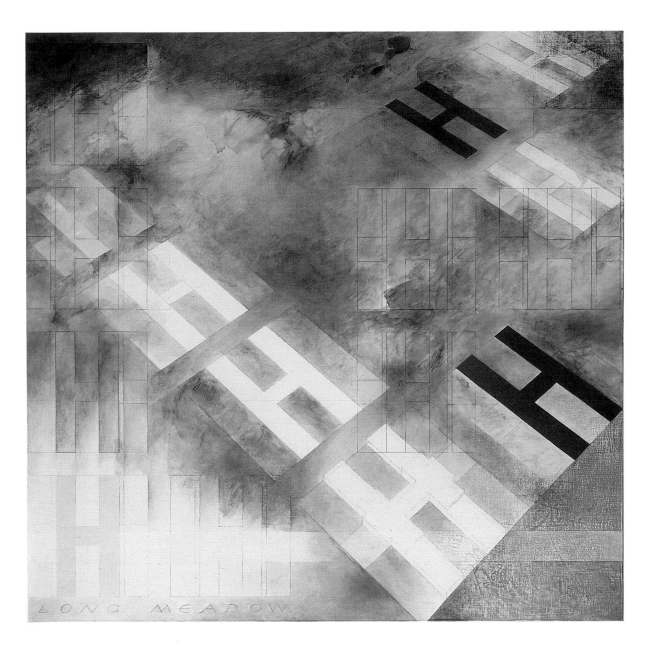

LONG MEADOW

rigorous and ruthless. It gets over the difficulty of the slow start, by which most of us pay close, deferential attention to the early rooms of an exhibition and are too tired, well before halfway, to take in the climactic masterpieces if it's a retrospective – or much else, if it isn't, of what it is. I commend my approach to you, for what it is worth – it may suit you; though it is not easy to apply if the gallery is overcrowded. Simply: I walk at a brave, purposeful pace down the centre of each room as if I were going to pass right through, and wait for a picture to call me. And they do, surprisingly loud. We tend to underrate our peripheral vision, it is quite acute; adapted for danger and the possibility of passing enemies and snobs. It is nice to be able to put this primitive adaptation to civilised use. Size is not a problem. Even quite small pictures in insignificant frames can cry out, 'Over here! Quick! Don't miss me!'

I had been told that there were over a thousand works by women at the Tate, by over two hundred women artists. I thought that this method ought to stand me in good stead. As it turned out it was just as well that I arranged all the same to meet Dr Collins, Curator of the Modern Collection, who was to point out to me, to save time, which of the approximately six hundred works on display at the gallery at any one time (out of over five thousand owned) were by women.

Tie up my bike to the railings, turn my back on the Thames, in through the revolving doors. Divisions of labour; there were men and women security guards searching bags. Only women at the information desk. Only men taking bags, coats and umbrellas. Dr Collins was a woman, an erudite and entertaining person. A morning's browse? After only fifteen minutes we repaired to the coffee shop (men and women together behind the serving counter), having seen all that there was to see. At most half-a-dozen paintings and three sculptures by women currently on display out of the thousand odd. I was amazed; I don't know why. If you asked me to name some women artists that's about it exactly. I could think of half-a-dozen. Add Berthe Morisot, Vanessa Bell, Frida Kahlo and Leonora Carrington to the three I first thought of. Dr Collins assured me there were a lot more paintings, in the stores. Just very few on display. No wonder I am ignorant. Of the works I saw several were already 'gone', chosen by another con- tributor. I had seen one Frink, one sculpture I liked by a woman I didn't know,

41

of two short stout men, a Vanessa Bell, a big picture of a dance of life – but nothing that had shouted at me and nothing that was going to haunt me. My brief became a little paradoxical (and also, incidentally, a lot longer). Looking at exhibited pictures was one thing. Unearthing them where they hung in the stores, another. What was to be done? Dr Collins suggested a way.

I could come back another day and look through the files of photographs which document every picture, and if any of those images, in black and white, grabbed me, I could be shown the originals down in the stores, on the sliding racks. Had I been able to give Dr Collins some idea of what I am likely to like she might have been able to pre-select on my behalf; but how do you describe what you like, why some pictures speak? I could have shown her a postcard or two, perhaps. In glorious colour. Whatever else, the undertaking was to turn out to be good exercise, as well as revealing a variety of routes to me as I cycled between Marylebone and Pimlico in fair weather and foul.

So – to the files. A shelf-ful of hefty black plastic ones, ninety-five or so, me flipping through, waiting to be arrested, stopped in my tracks – a bit like a casting-director looking through *Spotlight*, and maybe even less reliable. My actress's heart bled for the artists. Was this how all those months and years of effort and pain and discipline were to be appraised? Selected or rejected on a whim by an insufficient amateur? Yes, that was how. I noted down each arrest, and returned to look again at any I still remembered at the end of the hour and a half. Heavy work. As I came to the end of one file Dr Collins was by my side with the next. At no point was I to be left alone. Might this become a problem? Looking at pictures of pictures was one thing, but when it came to the originals? It's such an intimate exchange. You need privacy, looking at a painting. (As opposed to a watercolour. Really? Why do I think so? Discuss.) It might turn out a bit like going to visit someone in hospital or prison. Time would tell. In the end the list boiled itself down to a round dozen and we arranged another meeting.

Appointment number three was to view in the stacks, history behind the scenes. Behind the frontal grandeur of the Tate building, an old prison built on a swamp – the one from which convicts condemned to transportation would embark for Australia. Here were offices of the officials of the Tate, grey on grey to counteract lives committed to contemplating colour. The

42

stores were down in the cream-painted belly, huge lagged piping running overhead, high temperature, high security maintained and intensified; combination locks, big red doors, with a small square of glass inset for those on the inside to peep through and check your bona fides.

A virus having struck down swathes of 'the men' who would normally have had the pictures out for us to view, we were let in, but had to do our own locating, by letters and numbers and gentle heavings and slidings of the huge racks, squeezing past and between with fingers crossed, hoping that whichever picture we were after, out of my twelve, would end up somewhere where it was possible for it to be seen, since we could not move them. If it is possible to see anything by fluorescent light.

We slid, we saw, we whittled. Some things were better in black and white. Some rejected themselves. What sort of thing did I like, Dr Collins had asked? The important thing, it seemed, was to be held and then haunted, and we were rather whizzing through. One painting, in what I think of for no reason as a Mexican style, clear, unshadowed lines and colours, was of a woman sitting on a chair in an empty attic room holding an animal in her arms. I needed to know about that animal. Was it dog or cat? It was dog. That ruled it out. I do prefer cats, as a kind, but even so I'm not sure why. A woman and a dog of course might be inseparable, mutually besotted. A woman can only persuade a cat to let her hold it for just so long. There was more between the woman and the dog than there could be between me and the painting. But I do remember her.

I remember Dora Carrington's view of the Lake District. A white farmhouse at the foot of green mountains with a beautiful old stone barn to one side, and what I took to be white fences but Dr Collins discerned were great lines of laundered sheets hanging out to dry. A woman's painting. But too green. Too crushed beneath the immovable peaks. And surprisingly little air for Cumbria. Once, in New York, one of those baffling misconceived cigarette campaigns put up one billboard vastly depicting the highway across the Brooklyn suspension bridge, blocked at the far end by a giant cigarette pack. It made you choke and clutch your throat and gasp for air. The mountains reminded me. I am not a great one for mountains.

On, on.

A couple of portraits, one of the artist about to go to her wedding, another of a man, another painter. Nothing that stuck. One large farming

scene: *A Land Girl and the Bail Bull* by Evelyn Dunbar. The eponymous heroine to the left with raised hand reaching. Large cows munching in a cool twilight, a mackerel sky. Part of the war effort, commissioned by the War Artists' Advisory Committee. Yes, I could live with that, but it's a bit careful, constructed. (Or am I reading that in because I had been told it was commissioned?) But next to it, a long and narrow and somehow pinkish painting; a very different day, though twilight too, just coming up for tea-time. A garden – a vegetable garden? It's hard to tell. In the foreground a large bed of bare brown earth. I remember a garden in digs I had in Manchester that looked deadly boring in March and then as the weeks went on, March to April, it transformed itself day by day into a bustling bursting herbaceous border. It's surprising that this picture is also by Evelyn Dunbar – the light is so very different, a smoky fading light that blurs, and a smell of bonfire. Perhaps she is just very good at light. Which is what it is all about. Here is something that might stay with me. Thank heaven. So I can leave it – we are nearly done with our dozen – and come back.

For the last on my list we have to visit one more store, much larger, with rooms off rooms, to see a painting whose black and white image only intrigued me; no more. The letter H, scattered half-a-dozen times at random in a geometric field. Not my sort of thing. The actual painting is still almost monochrome, but the sight of it makes my stomach lurch with fear. The light again. But this light is thrusting up from below through the blocks of the H letters, apart from two that are blacked in, blacked out. I recognise hell, that is the fear. As if the letter H stands for hell. But in fact I am recognising an experience of a vision of hell that has nothing to do with the hell of this painting. Driving for the first time on to the M25 one Sunday, a day of wind and rain, shifting clouds and a cold, untrustworthy light as clouds cleared and obscured the sun. The motorway was terrifying, a seething cauldron but ice-cold, steam and spray rising up to meet more steam and a perpetual motion of falling spray. And everything clear and cold. I said aloud, 'This is my vision of hell.' The coldness was a real shock. Rita Donagh's painting was called *Long Meadow*. The Hs are the H blocks of the Irish prison. That hell again. And once again it was the coldness, in the swirling, steaming light, that was the shaker.

*

I got home alright, on my bike. And a couple of weeks later made one more journey, to be sure and to choose. Once more in front of *Long Meadow*, better prepared this time and a little more composed and able to observe its composition, which is painstaking. But its presence is still as powerful and as painful. Studying more closely it is possible to decipher a grid of lines. More Hs. The Hs that surge at you are a raft floating at an angle on a surface of still more Hs, some of them thickened and filled in, shades of pale, some untouched. Black mists part, light boils through. There is colour after all, or a memory of colour, where the title is painted below, a dilute rainbow spectrum. The sense of movement is incredible. On the H that is bumping the bottom of the frame, there are low elevations drawn very faint. And doesn't that one form the angle of an L? The last letter. But ahead of it, in the distance the Hs that begin the word, a conveyor belt to infinity, eternal hell.

It is a relief to look again at the *Winter Garden*, bathe myself in happier memories, rosy dusks and the promise of tea. It is a walled garden but the walls here do not imprison, the walls have views away to the left over the roofs of neighbouring houses to hills in the distance; on the right the wall has espalier fruit trees trained along it. Paths, bordered by slanted up-ended bricks that catch the pink light, lead on either side away to the house at the far end, half-hidden by tall evergreens, cedars or wellingtonians. And is it a house or a church, rather grand, with beams, and a square tower with a pointy roof? This garden is very kempt. The trees have been lopped but not pollarded, twigs are thickening up nicely ready to sprout; a few glass cloches or frames lean expectant on the real frame at the bottom of this picture, just a hint of green at the thickness of the glass edges. The gardeners have just knocked off, beds dug over, time for tea. (That's the only small worry – there's no smoke in any of the chimneys. Surely somewhere there must be a kettle on?) A lovesome Garden, full of the right kind of order. Peace and promise.

So now, before I get on my bicycle again, must I choose between these two paintings? Can I choose? (Can I ever?) Not in fact. Because I shall remember them and because each returns me to the other. Bleak hopeless cold, and winter womb. Abortion and gestation. Proper despair and unearned paradise. Heaven and hell. Mellifluous *Long Meadow*: a paradoxical inferno that freezes the marrow in your bones; and a *Winter Garden* that warms the cockles of your heart. Would you choose?

Katie Campbell

NINE MEDITATIONS on

THREE FORMS

Three Forms (1935)

by

DAME BARBARA HEPWORTH

Let us begin with the obvious: the Egg, the Womb, the Breast. All the ovoid female forms; they hadn't escaped me. But look at the weight, the smoothness. That isn't chance, that concentration, no rough edges, no edges at all. Polished so smooth it's almost soft, like powder.

Ovals. Observe the shape: such simplicity and yet no two eggs ever look the same. No two, no three …

That urge to caress, to cradle the forms. That condensed, compact weight; the weight of a baby swaddled: a solid packet of flesh, a boulder, a rock. The urge to throw it, fling it, lunge it through a huge pane of glass, at a concrete wall, to drop it from a great height on to – what? – people passing, or simply the pavement below? To watch it smash into a million jagged shards …
And they'll never put Humpty together again.

II

Let us return to the form. 'Simplicity of form' – images from nature.
The stone: sea tossed, polished by the pounding of endless … relentless …
purged … of what? 'Purged of all impurities of colour and line.'

Stone … dead
 stone cold
 stone cold sober
 stoney hearted
 stoney broke
 stoney stare
 stones in the throat, in the mouth
 stoned to death.

Stone of Sisyphus.
Stone of the sepulchre: role it back to reveal …
Nothing. Emptiness. The saviour has disappeared.

(No, do not be sacrilegious.)
Build your house upon stones.
Hansel and Gretel, lost in the woods, their little stones stolen by the birds.
Milestones. Millstones.

<center>III</center>

Must get off these nursery rhymes. It's motherhood that does it.
Move back to something higher, something spiritual. The colour.
White. Or black and white. The cleanness of it. I can't bear mottled marble –
pink particularly – that inevitable suggestion of flesh. Grey streaks or brown
or black are tolerable, but pink never streaks, it stains.

Pure white, of course, is the ideal.
Pure white does not exist.

This colour isn't bad. Almost white, with only the faintest lines of grey, like
ash brushed from a cigarette, rubbed surreptitiously into the surface before
anyone can notice. Nothing but the guilty dust of ash. The rubbing in, the
web of grey, like veins on the surface of an egg, of an aging face, of a china
tea cup or a porcelain vase. All vessels age and crack, eventually. Then leak.
And then are rendered useless.

<center>IV</center>

Or what? The number – three: The Trinity. No that's a little pompous. Be
more mundane: 'Father, Mother and Little Baby Bear.' And which one is
which? Of course they will assume that the father is the biggest. Then the
mother. Then the baby.

One must not promote these false images of the family. Call it, what?
'Mother and Two Children.' No, say 'Mother and Twins.' No question now,
the mother is the big one. And what of the discrepancy between the twins?
Why deny it: equality is a delusion. Always one is more talented or charming
or intelligent or capable. Always one is better loved. Even with twins there
is always a first born, an eldest, a bigger, a brighter one. And the mother in

50

this version seems rather twisted, awry. A rock rolling off course down a very long and very steep hill. Bumpity bumpity: Jack and Jill.

Perhaps not twins, perhaps ... triplets. Three. The eternal triangle: two females and one male, two girls and a boy. Of course they will say the male is the perfect sphere off on its own. And the other two will be seen to represent the imperfections of the female. In fact they are not imperfect, they are simply unpredictable: each face is different, each shift produces a new surface, a new interpretation, not the bland predictability of the hard and scrutable sphere.

But of course this is no more an accurate account of the piece than any other.

V

It isn't totally random; the artist has an idea what the finished work will be before she begins.

It's the formality that draws me, the still, hard sereneness. The space between the forms. The arbitrariness of mass. The distance so precise and deliberate.

But ultimately it comes down to chance: why here and here? Yes, she did choose to place this one here and that one there and the third one in that particular spot, but why those sizes and those shapes and those spaces in between?

And why three? The eternal triangle. Is three so much more interesting than two? And what of the spaces between them? What tension holds them together? Or does it in fact keep them apart? Or perhaps it simply keeps them in place, keeps them from rolling off the platform and out of the frame altogether.

VI

Oh for the time and space and money to work big. All this compression: this as that. Metaphors. How liberating it would be to create on a monumental scale. This perpetually confining oneself: sculpture in miniature. Baby sculptures. No, that is pathetic – call them maquettes, models for a larger idea. Call them 'ideas in embryo' ...

The smell of marble. To live with each piece. To know each curve, each plane. To study the material like one studies one's lovers or children. To know from which stone each form will be fashioned.

One must be careful not to bruise the stone. Listen to each hammer blow. Listen for the faults and weaknesses. Even tiny pieces can shatter or crack.

VII

No human forms here. It's the solidity that appeals: the stasis, the silence, the absoluteness of those clean, abstract forms. Not wanting, not needing; they stand complete and independent. No pierced masses here: this is the hole in reverse.

And so inevitably we come round to the hole. The pierced form. The broken space, the symbolic absence which is its own presence, which links two separate spheres. Here we have the hole made manifest, the famous absence made concrete: that openness between the two opposing – or harmonizing – bodies. The absence which links, the link which separates.

VIII

Call it an eye, a nose, a mouth: anthropomorphise it once again. The sphere is of course the nose, and the face is the face of a clown: every feature ironed out, exaggerated, bled of individuality to make the viewer laugh.

The long oval is the mouth, the smaller oval the eye. One eye: it will have to be a Cyclops, or an Egyptian hieroglyph or perhaps a Picassoesque

portrait. One eye is sufficient to convey the concept of eye – the second eye is assumed. Unless the character is blind: Oedipus who couldn't bear to see what he knew to be the truth. Or the great cuckolds of literature: Uriah the Hittite, King Arthur, Monsieur Bovary, the ones who turned a blind eye. Or Tiresias who saw too much and in punishment was blinded.

<div align="center">IX</div>

Stone snaps scissors

No, leave the metaphor. Let us return to stone: placed in fires to absorb heat, in beds to warm damp sheets, in ovens to bake bread. The passions that it can contain – cold stone.

Nude (c 1922–23)

by

VANESSA BELL

Depressed and disagreeable and fat –
That's how she saw me. It was all she saw.
Around her, yes, I may have looked like that.
She hardly spoke. She thought I was a bore.
Beneath her gaze I couldn't help but slouch.
She made me feel ashamed. My face went red.
I'd rather have been posing on a couch
For some old rake who wanted me in bed.
Some people made me smile, they made me shine,
They made me beautiful. But they're all gone,
Those friends, the way they saw this face of mine,
And her contempt for me is what lives on.
Admired, well-bred, artistic Mrs Bell,
I hope you're looking hideous in Hell.

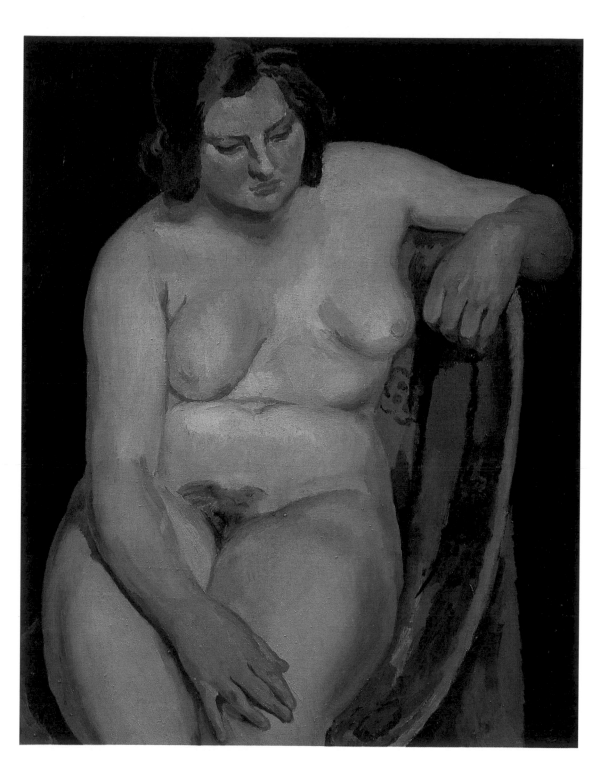

Maureen Duffy

Still Life with Pomegranates

(1963)

by
ELIZABETH BLACKADDER

Those Persephone pips, did you eat them
after the life was dismantled
the last drain from the white jug cat-lapped
the empty coffee pot black as Stephenson's
Rocketting smokestack back on the stove
then lay yourself down to dream
on the hot striated rug?

We live flatly, patterned on time
you seem to say, and that renascence
discovery of 'the art of prospective in scenes'
is just a trick of theatre conjured
by wavering footlights, the tawdry costumes
and masks to keep the children glamoured
forever on the edge of their seats.

Here it's as if there were no beyond or below
only our ancient or quotidian
artefacts at rest on a white ground.
You paint perfection of petals
in bruised iris and flagging tulip.

Yet these succulent squares are seeds
that might drop roots or lift stems
and there's no Lazarus raising
without dying, going down into dark
beyond Demeter's reach, sunk into
those gloomy arms below your painted
surface of what we have and can only lose.

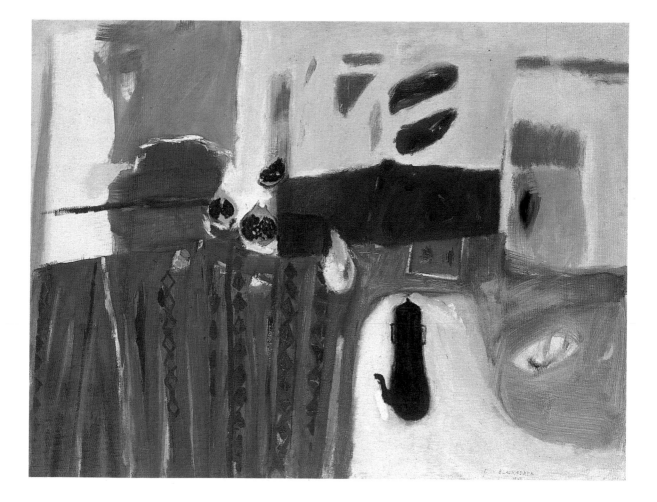

Beyond the window are hills, waters
to look out on; land and seaskips
your gaze also flattens til they become
more than themselves, paysages for voyaging.
Always what isn't there resonates through.
This is the language of spaces, white nights'
omissions you lay your jewels against
to burn evenly. Demeter when she descended
pleaded on her knees in the world of shades.

'How many,' the black king asked her daughter,
'have you eaten?' That half dozen, crunched
til the juice ran, kept her in darkness
and us too six months of the year.
Was it love held her down? She might have
 risen
into the upper light and air. They were only
fruit after all. You've painted seeds enough
for oblivion. They thrust their shoots
piercing the bright surface; and we are
shot through, bruised with Hades' heel.

The Convalescent

(1918–19)

by
GWEN JOHN

A pale young girl with an oval face and long dark hair sits in a brown cane chair. She is looking downward at a letter; or perhaps, having read the letter, she is now lost in her own thoughts. It is a room in which only the figure of the woman is important, so it seems appropriate everything else should be suggested in the same tones that convey her presence. The browns and pinks on the lids of her eyes are picked up by the colour of the teapot and the same brown is splashed on the walls.

Like so many of the women in Gwen John's later canvases, the sitter has the air of being alone and unobserved. Her hair is casual, and she wears a shapeless, blueish-mauve dress which gives little indication of the body beneath. She seems to occupy a space where the gaze of a lover has no importance. The brown teapot and the delicate pink cup suggest some attention to a quiet, domestic comfort, but whether she is taking care of herself as befits a woman recovering from illness, or has some friend to attend her is uncertain. The world outside barely impinges. The soft cushions and pastel colours call up the strange timeless waiting of convalescence. As a woman the model is, as it were, off duty, and seems content to be so.

Since this is not a self-portrait, all these associations are in a sense fictional; the model is observed by the painter and knows she is. The sitter, according to Susan Chitty,[1] is the same girl Gwen John was to paint later as *The Girl in a Blue Dress*. We might, of course, be picking up something the painter has intuited in the sitter's frame of mind, but most likely we are witnessing the transfer to her of Gwen John's own emotions. This painting, probably made in 1915, dates from early in Gwen John's finest creative decade, and these emotions are worth pondering.

Gwen John had been ill with 'flu and pneumonia in the spring of 1911, and thereafter, since she failed to give herself the least pampering, the illness recurred whenever she was caught in a shower of rain. One of the reasons she used herself with such neglect over those years, one must suppose, was a general disposition to see herself as unimportant. The same valuation of her worth no doubt affected the course of her long relationship with the sculptor Rodin. For all her habitual indifference to her body's needs, however, she was well aware of its erotic desires.

Gwen John was a woman of undisciplined passions, and that is what makes her world of pastel colours and gentle sitters so compelling; we sense the paradox between her own nature and the world she transmutes into art.

64

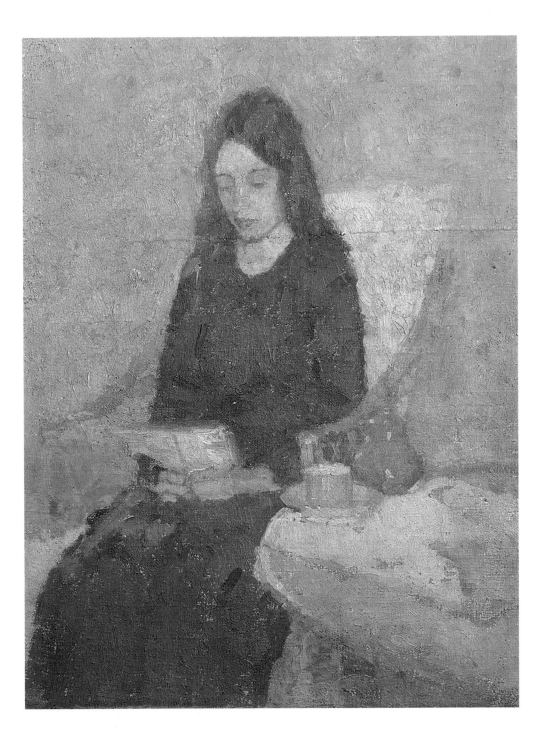

'I don't live calmly like you and the rest of the world,' she wrote to Véra Oumançoff. Even in her childhood, for all her shyness, she was a possessive daughter; indeed, she successfully prevented her father's remarriage. After the years as a student at the Slade, she ran off gaily in 1903 to hitchhike through France with Dorelia, the girl her brother Augustus, though married, had already sought as a lover. The two girls on their trip through France were more like genuine gypsies than anyone in Augustus John's painting. Gwen was as unconventional sexually as her brother, full of erotic life, loving both women and men, and attracting women particularly easily; on her travels with Dorelia, a beautiful girl from Toulouse left her husband to be with her, but Gwen John imperiously refused to see her when she arrived.

Her passion for Rodin, however, was of another order. She met him at the studio of another sculptor in Paris and was awed at the prospect of sitting as a model for him. He was then sixty-three and at the height of his fame. Perhaps sensing her excitement, he treated her tenderly, allowing her to warm herself thoroughly before asking her to undress and pose as his muse, with her right foot on a high rock, her head bowed, and her mouth open.

That Rodin was a man of ready sexual appetite is indisputable, yet Gwen John was not a likely recipient of his desire. She was young and thin, and he preferred women who were between thirty and forty, with firm flesh and mature fullness. 'A young girl is a poor thing in comparison,' Rodin averred. However, he found her an acceptable model, once she had taken off her clothes, while she took pleasure in being naked in front of him. At the end of the day, he lit candles, and seduced her by their light.

The intensity of her response may have surprised him. Their love-making gave her exquisite pleasure; but she was also making love to the Great Artist as well as the man. Flodin, in whose studio Gwen John had met Rodin, was a former mistress who was occasionally present at the encounters between them, but Gwen John made no complaint. She had found the man who was to make her life significant. That Rodin continued as her lover for nearly ten years says much for the strength and persistence of his own libidinal powers. 'Sex gives me a headache,' he began to complain, however.

As time went on, Gwen John had to learn to accept the presence of many other women in his life, and his failure to commit his own to her.

Yet, her submissiveness did not come from a cool sophistication and she did not behave decorously under emotional pressure. When she thought herself displaced from Rodin's affections by the witty and elegant Duchesse de Choiseul in 1904, she spied on them both from a cupboard; and once rushed out at the Duchesse from her doorway to accuse her of cruelly exhausting Rodin with foreign travel and high living. She behaved rather like a sulky and self-destructive child, declaring (when she could ill afford it) that she would rather wear a cotton dress all winter than take another penny from her unfaithful lover. Perhaps understandably, Rodin advised her not to come to his studio again without invitation; but she could not take this advice since she continued to evaluate herself entirely through his eyes, reading all the events in her life as they related to him. She even found the loss of her cat harder to bear because she was convinced Rodin could not love her once it was gone. Rapidly, she learnt to tolerate the Duchesse, and several others.

In Rodin's presence, Gwen John always spoke of herself as an amateur; understandably enough, since he was at the peak of his powers and she had fallen so completely under his spell. In the same spirit, she chose to draw rather than paint. Much as she learnt from him, her obsession with his love took five years out of her painting life. Amazingly, however, their relationship did not finish her off; from somewhere, even before it was over, she found the strength to put 'all that energy of loving into her work'. *The Convalescent* is a painting from the year in her life when that transition began to seem possible.

Gwen was living in Meudon, a suburb in Paris, when the First World War broke out, and although many British residents in Paris left very soon afterwards, she was disinclined to go home. Rodin had by then all but ceased to make love to her, though she waited anxiously for his visits. When he appeared in her room after a long trip to England in 1914, he did not even kiss her, and hurt her by growling irritably about its untidiness.

She had to face real hardship during that first year of the war; money from her American patron John Quinn arrived at best irregularly, and she could hardly afford food or fuel. She had become ill and enfeebled, and suffered almost continuously from colds. In the summer of 1915, therefore, she set off for Brittany with the painter Ruth Manson, then living with her

child after being abandoned by her Italian lover. Ruth wanted to take her child as far as possible from the fighting, so they set off together for Pléneuf near St Malo in Brittany. Gwen John arrived there an invalid, much preferring to huddle indoors rather than explore the world outside. Soon she was walking at low tide along the sands and admiring the cliffs which were 'not spoilt by houses'. Moreover she began to paint with great fluency. As she wrote to her friend Ursula Tyrwhitt: 'I have had a tiring life for some years and so seem only now to begin to paint.'

Gwen John recognised the transition as having an inner, spiritual source. There was no obvious social agent for it. Villagers, some of them child models for her charcoal drawings, remember her as friendly without being particularly talkative. This was the time when Gwen John was introduced through John Quinn to Yeats' love, the beautiful Maud Gonne. It had taken some courage for Gwen John to take advantage of that introduction. 'I may be timid, but I am never humble,' she said of herself. Gwen John was far from indifferent to female beauty, and had enjoyed several relationships with her own sex. Yet it was not to that friendship that she owed her new fecundity.

While close to Rodin, she had been unwilling to describe herself as more than an amateur. Now she began to work with another kind of dedication, unmarked by the indolence which had been her greatest danger. Whatever else gave her that strength, it cannot have been a sense that her work was finding a market; she had shown little interest in the sale of her work. Even though Quinn supported her, she could not bring herself to send him the countless paintings rotting in her *grenier*.

Gwen John had converted to Catholicism in 1913, even while she continued to write passionate love letters to Rodin; now, however, it was to God that she turned to feel loved in return. 'The stars in the sky and the leaves of the plants on my terrace console me in the night. They are presents from God and tell me that he loves me.' By now the God she worshipped was a God who authenticated and blessed work above all. 'I must work every day and each day,' she admonished herself severely in her studio notes.

Her work became for the rest of her life, quite precisely, her salvation. In painting, from now on, she looked for all the tranquillity she had not found in her life. 'Each day is for work,' she wrote. 'Abandon yourself to

God's kindness, but you must work with fervour.' From now on she saw herself as 'God's little artist'.

Another denizen of Meudon, arriving in that Paris suburb about a decade later than this painting was the great Russian poet Marina Tsvetayeva. In exile, poverty and neglect she found a similar lonely stamina. In her essay *Art in the Light of Conscience*, Tsvetayeva referred to Blok's cruel remark about Akhmatova: 'She wrote verse as if a man were looking at her, but you should write it as if God were looking at you.' *The Convalescent* occupies her canvas with the same passionate detachment, and signals a recovery from more than influenza.

1 In Susan Chitty, *Gwen John, 1876–1939* (London 1981), to which I am much indebted.

A Lady Reading

(1909–11)

by

GWEN JOHN

A *Lady Reading* is a relatively early painting by Gwen John, and it speaks to the viewer in a very different way from those painted later, when she was at the height of her powers. It was probably painted between 1910 and 1911, and I feel she is addressing the viewer, the connoisseur, setting out to charm, to beguile. A decade later John would not have bothered about mentor, public, or patron: by then her brush had the assurance which gave her freedom, and greater subtlety of tone and texture allowed her to go for utter simplicity of composition.

Which is not to deny the beauty of this surprisingly small picture, small for the amount of detail in it, and the relative precision of outline. But to me the chief interest of the picture is as a statement of intent, almost an artistic manifesto. It tells us where John has come from, and where she intends to go. It is much more self-conscious than most of her paintings, and is almost iconographic in the way it is composed. It cries out to be decoded, 'read', in a way which her later masterpieces do not.

Solitude was immensely important to Gwen John. Increasingly, as she got older, she recognised her need for it as a source of spiritual growth. And one of her favourite themes as a painter was the solitary woman, by herself, in an enclosed space. Later on, her female sitters would speak directly of the spirit in a way which moves us profoundly, but in 1910 John has not yet arrived at this point of fulfilment, though she has intimations of where she wants to go, and how to get there.

The woman in this picture is rather obviously posed, a bit awkwardly. Is her foot on the chair? Or is she perched on the edge of the table? John was appalled when a friend mistakenly thought the latter. Part of the difficulty no doubt stems from the fact that John was using herself as a model. And she chose a standing figure, despite problems of perspective, because the composition was intended to echo the great Dutch school of interior, domestic space, and in particular its greatest practitioner, Vermeer.

As in Vermeer, the window is on the left, lighting up the female figure. John has made her seem timeless, with long, undateable garments and loose hair. As in Vermeer, we look in as the unobserved observer, on a scene of private domestic intimacy. Where a Vermeer woman might be reading a letter, this figure is absorbed in a book. And, as in Vermeer, the background is not vague, but lovingly detailed: the curtain, carefully draped, some pieces of furniture and, most importantly, pictures on the wall behind.

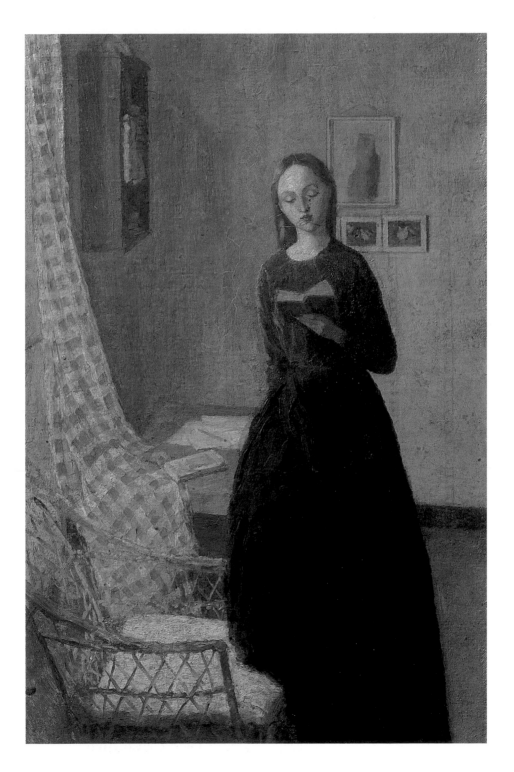

It is when we look at the pictures just behind the head of the standing figure that really important differences begin to emerge. The two lower pictures are by John herself, of her beloved cat. The third cannot be positively identified, but to me it looks like a female nude torso.

As a student Gwen John loved Dutch paintings, and it is not difficult to see why. They celebrate domesticity, the lives of women and children, simplicity rather than heroics. And yet, and yet ... the differences between this Gwen John and a Vermeer are as important as the similarities. Gwen John was first and foremost an artist, not a housewife, and this is very pointedly expressed in the three little pictures. She was also a woman who modelled in the nude, for amongst others, her lover Rodin. We are light years away from seventeenth-century Holland.

The Dutch masters were of course men and, whilst the puritan ethic honoured women, it did so in a strictly domestic framework. Vermeer's women tend to be earthy, buxom and fleshy. One beautiful lady reading a letter is obviously pregnant. These women are wives, comfortably off, and the source of comfort. Gwen John's lady, on the other hand, is slim and virginal. Although she used herself as a model (reflected in the wardrobe mirror) she changed the face to that of a Dürer madonna, suggesting contemplation and spirituality, not a brief respite between organising lunch and dinner. And there are other differences. Dutch interiors are clean but far from spartan. The women wear expensive garments, and their hair is carefully dressed, whilst the rooms in which they stand boast carved furniture, large oil paintings, heavy drapes and musical instruments. Such pictures are, in fact, a celebration of bourgeois comfort and wealth at a time of great national prosperity.

A Lady Reading could not be more different. Gwen John was very poor all her life and, if it is going too far to say she actively sought it, she certainly did nothing to avoid it. Her picture celebrates the simplicity of poverty, of humble self-sufficiency. Her figure is plainly dressed, with no ornament of any kind. Her hair hangs naturally, without curls or ribbons. The room, too, is cheaply furnished. The curtain may be carefully draped in the Dutch manner, but is made of cheap gingham. The basket chair is beautiful, but cheap, as are the plain deal table and bookcase. Paper and pencil on the table, together with the pictures on the wall, express a more profound self-sufficiency: that of the creative artist.

*

A Lady Reading was one of a series of pictures which John painted to express her delight at having a room of her own. A few years before this particular picture was completed Rodin had given her the money to move out of a sordid hotel in Paris and into an unfurnished room. For the first time she had a space she could call her own, where she could take pleasure in a few modest possessions. At the time of her move into that first Montparnasse attic she wrote to her lover: 'My room is so lovely. If you knew how charming I find it you would think that I exaggerate its beauty perhaps. But I am going to do some drawings or paintings to show you what I find so lovely in it. I am going to do some in the mirror of my wardrobe – with myself as a figure doing something. They will be like Dutch figures in subject-matter.'

Gwen John was to portray herself in that and subsequent rooms not only demurely, in the Dutch manner, but in the nude: sitting naked on the bed, or standing with sketch pad in hand. For this is where she waited for Rodin to come and visit her as a lover, suffering in solitude when he failed to arrive. A room of one's own gives freedom of another kind, though for John it was so often abject servitude. Despite the symbols of self-sufficiency in *A Lady Reading*, we should perhaps read something else into that somewhat idealised figure, apparently so absorbed in her book – romantic invitation? Are those modestly lowered eyes all too aware, after all, of a man's gaze?

Every artist, working in whatever medium, knows that personal emotions lead to all sorts of subterfuges as we try to cover our tracks. *A Lady Reading* is a very personal picture, as its iconography reveals, but John tries to conceal the fact by a mode of stylisation which is normally quite foreign to her. She wrote to her friend Ursula Tyrwhitt: 'How dreadful that you should think that the girl is sitting on the table and that she is me ... You are so right about the head. I tried to make it look like a *vièrge* of Dürer, it was a very silly thing to do. I did it because I didn't want my own face there.' In a similar painting she did for her patron John Quinn shortly afterwards she put in her own face but removed the two cats. She also removed the bust standing atop the bookcase, which intrigues me: was it a Rodin copy?

A Lady Reading is not a typical Gwen John, but it tells us a lot about her, if we know how to read it, particularly what she aspired to at that point in her life: privacy, contemplation, and soul. In the years ahead she would achieve all these goals as an artist, if not as a woman. Only in God would

she find the peace which emanates from this small picture, and the modest self-sufficiency it celebrates would turn to suffering and self-neglect. In return she was able to paint some of the most moving pictures ever executed by a woman.

Margaret Forster

Haystack in a Field

(1967)

by

SHEILA FELL

The first painting I ever bought was by Sheila Fell. I went to her studio in Redcliffe Square feeling uncomfortable and even embarrassed, thinking how awful to be an artist, having to put up with prospective buyers coming to gawp, whereas a writer never needs to see anyone read their books, thank god. I kept wishing, all the way up the steep flights of stairs, that I could go and look without Sheila being there. I imagined she must be feeling the same.

I was wrong. Sheila didn't care who looked at her paintings or what they thought of them or whether she sold them. She was perfectly at ease, seemed to me to enjoy showing her work. There was a confidence about how she propped up canvas after canvas which made me in turn relax. I don't know why I'd been so apprehensive – after all, we had Cumberland in common, there was no need for me to explain why I was drawn to her work or to fear I might not find something I liked. What I missed, exiled in London, she missed: the landscape of where we had both been born and brought up, and not just the sight of it but the whole atmosphere surrounding it.

I like to think I know that landscape as well as she did. It isn't the landscape of the better known Cumberland, of the famous Lake District part, but of the Solway plain. I knew it because I seemed to spend most of my adolescence cycling through it. I lived in Carlisle, on the west side, and my favourite bike ride was to Allonby on the Solway coast, thirty miles or so away. I'd cycle there along the direct route, through Wigton and on to Skinburness, and then it was a flat coast road all the way. Coming back, I'd take the empty Westnewton road, north of Aspatria, and slowly drift through what was Sheila's country.

It is arable land, always being worked, never entirely empty of figures ploughing and planting and harvesting. There are trees and hedges of course but around the bleak little town of Aspatria the earth itself seems to dominate. The colours are predominantly brown, dull red, russet and black with the occasional edge of ochre yellow. Except for the sky. Here, the sky is almost oppressive – it seems to press down on the plain and bully it. The winds come mostly from the west, from the sea, and move the clouds along at a frantic pace, rushing them towards the hills in the south. This is what Sheila captures so completely, this turbulence of the sky, its impatience, the way it dominates the land. People in the fields are always looking up at the

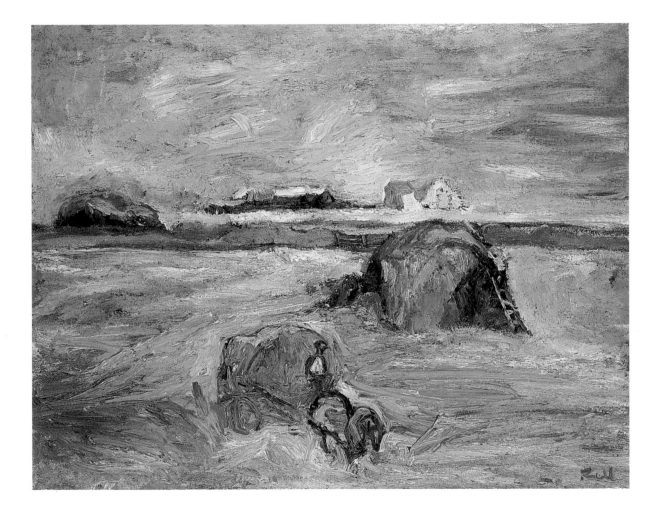

sky anxiously, almost fearfully, knowing it forecasts so clearly the arrival of rain or snow or storm. It is all there, to be clearly read: a black mass of cloud in the far corner of one's vision and there are perhaps thirty minutes to seek cover before a torrential downpour. Looking at Sheila's paintings the eye is invariably drawn first to the top half of the picture, to the sky, before anything else is seen.

Under these mostly doom-laden skies the lives of the people are hard. These lives are in her paintings, there is always a consciousness that although nature is here, so is *work*. Sheila had no illusions. She didn't just see beauty, she saw struggle. Men and women working this land have to be tough. I see in her paintings, particularly in this one, an acknowledgement of how harsh the farmer's life is, how unremitting the toil and never-ending the battle against the elements. Those impressionistic figures climbing ladders up haystacks or pulling horses' bridles to get carts out of ruts are exhausted but determined. The vigour of the painting itself, the sheer strength of the bold brushstrokes, echoes the labour in the picture. There is an air of urgency, sometimes of threat, in many of Sheila's paintings – there is a storm coming, or more snow, and the horse, which has surely been back and forth across the frozen field since dawn broke, is as weary as the man. But what I love most in this painting, apart from the story it tells me, is the light. Often, on that Solway plain, light brings the only comfort. The changes of light are so rapid and complete that it is impossible to believe they are accidental – they seem controlled by a masterly hand. It has nothing to do with sunshine – that is a different matter altogether – but comes from a change in the density of the clouds. They lift slightly, and the light increases; they thicken, and it darkens. Sheila catches the momentary lift time after time. Never, ever is the light static in her paintings.

The painting I bought in 1966 was also of a haystack in a field, but painted at a different time of year. The haystack had clearly just been made, it was golden and the field flooded with a red-gold light, the whole atmosphere mellow and rich instead of bleak and bitter. It was a large painting, much bigger than this one, and I realised as soon as it arrived at my home that however much I loved it I had no wall and no room to do it justice. I put it on the largest wall we had in the biggest room and still I felt I was insulting it – the power of the picture was too huge to be contained in our ordinary house. And the light was wrong. The painting

couldn't glow, as it wanted to – it needed a vast, empty room and a great distance in front of it. One day, I hoped, I'd take it back to Cumberland and find a house there where it could settle happily. But when, after thirty years, we found that house, and began to live half the year up in Cumberland, the painting was failed again. The walls were no bigger and neither were the rooms. So I sold the painting and bought another, smaller, Sheila Fell.

It was a terrible mistake. The moment the painting had been taken away I realised how stupid I'd been. So it had been overwhelming, too large, too dramatic to contain in either house but I shouldn't have let that matter, I should have found a way to keep it. I grieved for it and wished I could buy it back, marry it again after the folly of a divorce. But it was too late. And then, in 1990, I went to the Sheila Fell Exhibition at the Royal Academy and there, in pride of place, at the end of the longest room, the room it had always needed, was my painting. Its beauty was stunning. People stopped and stared and admired and I wanted to shout that what they were looking at was *mine*. I am not at all possessive by nature but suddenly I felt fiercely possessive. This glorious painting had been part of my life for so very long and I didn't seem to be able to grasp that I had wilfully let it go.

I went back to the exhibition day after day and on the last one became almost maudlin at saying my goodbyes. I don't know who owns the painting now – it merely said 'Private Collection' in the catalogue – but I doubt if I'll ever see it again. In a way, that's better than being able to go and look at it hanging in a public gallery – I'd only go on torturing myself with wanting it back. I can see every detail of it in my mind's eye anyway. It lives in my head. I can recite it like a poem, and so in a sense I can never lose it.

And I have other Sheila Fells to console me, three of them. One is yet another haystack, though it is such a dark painting the haystack is almost invisible. It is a brooding, sinister picture, the light almost gone on a dank spring day. It belongs to another era in Sheila's life, to the time when she was so interested in Van Gogh. I don't respond to it as strongly as I do to the paintings of the mid-sixties. But I love the painting I bought from Sheila in 1979, the year she died, aged forty-eight. Again, I went to her studio. My husband, Hunter Davies, had just interviewed her for the *Sunday Times*, she'd told him how she was 'always longing for that magic moment when I've done a bit of work and nothing seems real ... You go back to everyday life

... and it all seems strange. You know that what's right is inside you.' The day we saw her, she'd just experienced one of those 'magic moments' and she showed us the 'bit of work' which had given them to her. It was the last of a sequence of paintings of Allonby and the Solway coastal village, and I loved it on sight. We bought it and carted it home there and then, and two days later Sheila fell down the iron staircase up to her studio and died.

I will never let this painting go. I have learned my lesson. Paintings that have such deep, personal meanings are not to be disposed of as mere chattels, after all. I don't just look at this Allonby painting and love the exuberance of it, and admire the movement of sea and sky – I am in it, on those Allonby sands again, the very place I learned to walk at fifteen months and where every year since I've dodged the waves and watched horses galloping back to the nearby riding stables. Looking at this last painting of Sheila's is not anything as sentimental as an exercise in nostalgia. It is much more than that, a weird feeling of not being *here*, but *there*, in the painting and beyond. Perhaps all art, of whatever kind, tries for that feeling. One can admire technique and style and scope but, without feeling, surely none of these matter.

Sheila Fell's paintings are, to me, all feeling. She felt Cumberland, it was as simple as that. I look at them because I want to feel what she felt and only incidentally because they are beautiful. When I am actually back in Cumberland I walk her paintings. Often, returning from such an expedition, I find myself nodding at a Sheila Fell, agreeing with it. One day last winter I found myself walking near Aspatria, about three miles to the north-west, along a road I'd never used before. It was stingingly cold and I hurried, head down, scarf almost obscuring my face. I heard the noise of a tractor and looked up, over the black, dripping thorn hedge. It was the opposite of being transported by a Sheila Fell painting into the landscape: this time, the landscape celebrated her. It was pure Sheila Fell – the sullen sky, clouds interlaced with glints of gold in all the snow-laden heaviness, the frozen ruts of the field ribbed with slush, the black tractor trundling mournfully, patiently, towards the gate. Sheila may be dead but everywhere the landscape remembers her.

Flower Table

(1928–29)

by
WINIFRED NICHOLSON

When I first saw this picture in the Tate I thought, 'Oh yes, Cumberland.' This is the remark that anyone who knew anything about Winifred Nicholson would have made. She was Cumbrian. Her Cumbrian roots are ancient. She was a Dacre. 'The earth of Cumberland is my earth,' she said, 'way back to Medieval, Celtic and Bronze Age times,' and she lived for many years of her long life in a farmhouse called Banks Head that looks across the huge span of the Irthing valley towards the Lake District mountains. The house is built with stones taken long ago from the Roman Wall.

Yet I hadn't known any of this. I had loved Winifred Nicholson's paintings, the few I had seen which were the abstracts, the Paris pictures, the paintings in the sea-light of St Ives and the honeymoon pictures on Lugano at the lovely Villa Capriccio, flowerpots with the lake behind them and the best known of all her work, *Mughetti*. This small oval bunch of lilies-of-the-valley loosely wrapped in tissue paper which is 'interchangeable with the white mountains', she said held her 'idea of marriage … of love and the secret and lovely things it unfolds.' Ben Nicholson, her husband, thought that the ideas for her abstracts came largely from this painting.

She and Ben Nicholson had found Banks Head later in the twenties. Ben, who in Italy had ignored the view and made himself a windowless room, now proceeded to knock out the old square windows of the farm, smashing its symmetry to extend its horizons, replacing them with gawky oblongs to 'let in the view of the hills.' One wonders what Winifred thought of this, especially as Ben left her and their three children quite soon after, to live with the sculptor Barbara Hepworth. Windows were of all kinds to Winifred on her home territory. She saw in blinks. 'It takes several blinks in the dark to see colour.' She could paint immense distances from inside a crack, as she could paint the endless dazzle of sunlight across a landscape by a few suggested splashes of magenta, orange, green, yellow flowing through the keyhole and down the hinges of a closed door.

There is no keyhole, door or window to let in the sun on *Flower Table*. It is a painting of the corner of a stone-walled room or part of a passage, the light coming from behind the painter who is sitting with her back to the out of doors, maybe with the front door open, though I'd guess not. Few front doors stand open along the Roman Wall. It shows a flagstoned floor, the end of a rag rug, a bink with flowers in pots on it and a bulging, rough

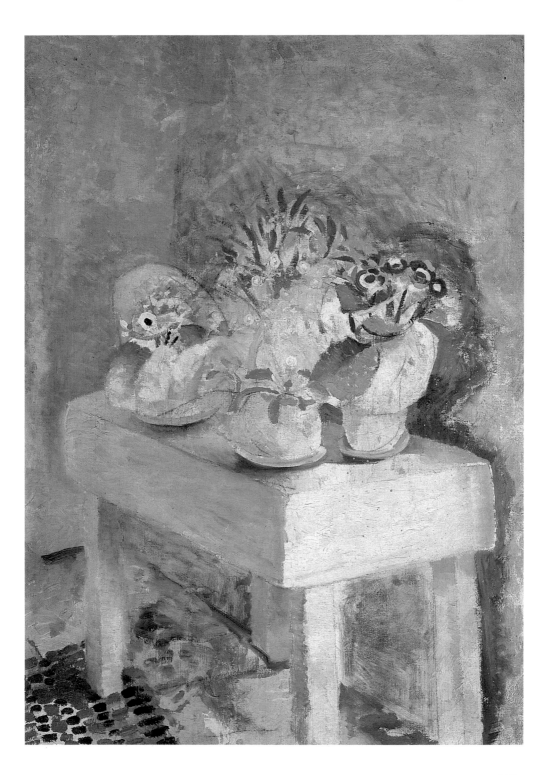

wall above and to one side, probably lime-washed. (I am told it is actually painted light green.) It was the lavender and light ochre shadows and the light, and the particular creaminess of the flagstones that opened up my memory so that I knew that it was Cumberland – this rather than the Cumberland rag rug which is not a pattern I'd seen, or even the bink which had true binkish dimensions and depth but is of wood instead of the usual pink stone. And Winifred Nicholson calls it a table.

'Bink' is a Scandinavian word in use since the thirteenth century and probably long before. It is still used today in the north for any good strong surface for putting things on. I have one in my garden at Crackpot and we sit round it in summer and look down at the River Swale. Mine is rose-brown stone, a smooth slab with rippling flaky lines on it like the sea coming in. When I was a child there was a much bigger one, like a long shallow sink an inch deep, in my grandparents' farm kitchen in West Cumberland, below a deep window-sill. The original handmade window held nine small square panes, three and three. The third square on the right of the middle row had been made into a little door through which my grandfather's great hand would be thrust every morning for 'ten o'clocks' and on his fingers would be hung at once the wire handle of a tea-can and a bundle of big slices of bread and butter while he was still yelling, 'Clocks!' like a general roaring out, 'Charge!'

The light from a wide sky shone down on this bink which was the centre of the farmhouse. Food was prepared on it, washing and washing up done on it and my grandfather shaved from it glaring at a small mirror nailed up on a window bar. Chickens and turkeys were plucked and drawn on it and stone upon stone of potatoes peeled at it into a bucket for the men who came in from the fields at twelve o'clock to eat apart at the round leather-covered table at the end of the kitchen. The family ate at a long table down one side. In the evenings I used to sit in the black rocking-chair with its scratchy cushion covered in a pattern of red birds. From the fire branches stuck out far into the room and coal glowed far back between the black oven and the copper. Winifred Nicholson has a painting of her kitchen fire, *Fire and Water*, with our old black sooty saucepan on the bars. Its lining is like solid silver, which I had forgotten.

I would sit watching Molly, the hired girl (she arrived when she was fourteen and left when she was over fifty) washing herself before going out

for the evening with her young man. She had dozens of these in procession, but never married. First she brought water from the water butt in the yard, so soft it hardly needed the block of green unscented soap anywhere near it. She topped up the washing-up bowl with a pan of hot water taken out of the copper by the fire, sliding the thin shield of the lid off with a scraping noise and a clang. Then she took the bowl off the bink and stood it on the floor and sat down near it and washed her feet. Then she dried her feet on the grey rag of towel from behind the kitchen door, picked up the basin and put it on the bink and washed her hands. Then she took off her apron and blouse and washed her arms and shoulders. Then she wriggled out of her skirt (Quick, look – see no one's coming) and in the same water washed her face and ears and neck very thoroughly, scrubbing them dry on the same bit of rag. She never used make-up and all her life had the complexion of Wordsworth's lakeland beauty, the Maid of Buttermere, who probably washed in the same way.

I first met our Cumberland bink when I was set down on it in a Moses basket when I was six months old. It was a snowy Christmas. I had been brought in the basket from the other side of England on the north-east coast in five different trains to be shown to my grandparents for the first time. When we all alighted from the train at Leegate – the station master used to run with a little set of steps as the platform was short: we always waited for the train to pull out and then crossed the line – my parents, holding a handle each, climbed up into my grandfather's farm cart pulled by Daisy, a one-eyed grey horse who always, poor thing, slithered and blundered down the fell to the farm, with us humped like Russian peasants in the cart.

Our farm was further to the south-west than Banks Head, nearer to the purple mountain, Skiddaw, that Winifred Nicholson was looking across at from the north. Not far behind us was the Solway Firth and beyond that we could see the Scottish mountain, Criffel. My cradle was set down on the bink by lamplight and Molly and my excited grandmother, who wore black to her toes and a pie-frill collar and a gold brooch with three corals in it and looked like a tiny duchess who had by very innocence, escaped the guillotine (goodness knows where her genes came from, she looked too much like porcelain for the Bronze Age), exclaimed and admired. My grandfather paid little attention. I was not a boy.

The kitchen, with its whitewashed walls, was my beloved place for years. Sitting on the cold bink ('Ere, get thysen yon cushion') Molly told me all manner of things about love. I watched the farm servants though I couldn't understand them. They were often starving Irishmen who slept across in the barn. Only ten years before I was born my father and grandfather used to go to hirings in Wigton market and pick farm servants out like animals. They were taken on for six months for five pounds and their keep, and given a shilling for luck-penny. My grandfather was a terrible and erratic man, but often kind, and would tend to choose the weakest-looking men in the hirings. My grandmother was happy to feed them up and Molly did romantically well amongst them. The only one, I think, who could resist her green eyes was an Italian prisoner of war in 1942 who looked like Raphael, spoke no English and gazed miserably at the eternal potatoes, peeled as was the custom with all the eyes in. He was lucky to have butter though, and milk and eggs through the war, as were we. All the milk tins and churns and butter bowls were washed at the bink and left there to sweeten every day.

Or was that the dairy? In the dairy there was a wooden bink more like the *Flower Table*, a deep, solid thing like a butcher's block. Molly used to turn and turn the churn handle, golden-armed, one-handed, my smaller hand beside hers. At intervals she dragged on the fag in her other hand. When the churn began to make the right sloshing noise she dolloped out the butter on the wooden bink and my grandmother took over, rolling and salting and patting and slapping until there was a row of gold cakes of butter which she decorated by rolling a wooden wheel across them that left behind a trailed pattern of acorns and oak leaves.

The farm was full of ancient patterns. There was the curious, lovely pattern Molly drew every afternoon except Sunday across the pink stone of the kitchen hearth with a lump of white chalk. She began with three vertical lines that divided up the space available. Then she swirled the chalk across each panel from top to bottom and side to side as easy and fast as if she were washing it over with a damp cloth, leaving behind her three perfect blocks of extended figures-of-eight. She let me try once, but it was absolutely impossible. She couldn't remember where she'd learned it. 'It's always been done.' I saw something like this ancient Celtic pattern years later on the

island of Chios. When the pattern was dry and shining white she covered it all up with the steel fender.

The rag rugs were a lovely design too and taken entirely for granted. Every farmer's wife made them. Some still do but now they've become cultish and have nylon in them. Old clothes and clean rags are collected over the year and patterns drawn out on the backs of flour and cattle-cake bags, the same as the backings for patchwork quilts. You cut all pieces to the same length and then pull the coloured clippings through the canvas with a long hook, and the rug comes up thick and felty, in colours and designs all different and all original. About the time I was in my cradle Winifred Nicholson was discovering the now famous Cumbrian rag rugs of Mary Bewick, a local woman, and her mother, Mrs Warwick, who lived next door.

Maybe the one on the floor of *Flower Table* is a Mary Bewick, but I don't think so. There are no designs of sheepdogs or cats showing. This one is more formal and neater than is usual, with rows of black and terracotta diagonal stitches. Someone's black wool stockings? Someone's flannel body-belt? A rag rug is all history. You lie on it and finger through the last decade's winter pullovers, somebody's matted Herdwick socks, rough sheep-coloured vests, little off-cuts of flowery curtains. The rugs are almost indestructible but not cherished. Sodden with mud off boots and dogs in winter, unhealthily full of dust in summer even after you've beaten them on the line or flung them a hundred times against the water butt, they get tossed on the midden after a short life. You can see that Winifred Nicholson's rug has only been trodden by painters' feet.

And, of course, the flowers that stand on her table are not what you'd see on a farm. They are set there as prisms to catch light so that it soaks into petals and slides along leaves: and to diffuse light through the tissue paper in which she has wrapped every pot. It is as if — if we were ever to think of this as a realistic painting — as if through a door just out of sight of the stone passage, people are visiting somebody sick and have been told not to disturb her. 'I think she's asleep. Go and look. Just leave the flowers outside,' and they have all been put down in their wafery twirls of wrapping.

Except that the flowers are all standing on little saucers taken down from a pot-cupboard so that they can reflect upwards on the flowerpots and undersides of leaves and cast beneath them a sooty but precise shadow to

balance the large, darker shadow that the whole composition on the flowery altar throws across the whitened wall behind – a wall so cool the flowers are going to last for ages, the slabs on the floor beneath so cold, and all out of strong, direct light.

To assert, to celebrate the constancy of the colour in the flowers, ('Flowers and jewels are the only things that express colour fairly constantly'), Winifred Nicholson has completed this painting by scattering over it a rainbow-coloured snow storm of glittering dust, like jewel-dust. It could almost be thought a mistake – a brush accidentally shaken – until you see there are a dozen different colours. They are like indoor raindrops or tiny particles that have floated from a flaking Renaissance ceiling, catching the light not in a sunbeam but in the refraction of a sunbeam – rose, silver, blue, green and gold. It is very daring of her.

Winifred Nicholson was obsessed by colour from childhood. She believed she could see colours other people could not. She believed that the human eye will see more as it becomes more sophisticated, that we see more than the cavemen did and as time goes on shall see more still. She died, I think, too soon to have heard of the astronauts who trained in a simulated space module to a much higher level than they were to encounter even in space, and reported that they had seen a colour they could not describe. 'Something like an intense green but like nothing we have ever seen before.' The shower of specks is not new colour of course, but it scatters over the smoothness and light of the flowers and leaves and nearly diaphanous tissue paper a new, metallic texture, a fairy – titanium – confetti.

We didn't have a flower table on my grandparents' farm. Farmers don't go in for flowers. Molly and I used to weed the clean, white pebbles (Winifred Nicholson talks of the intense colour in white pebbles and their wonderful smell, and she is right) in the tiny front garden, kneeling on old sacks, Skiddaw looking down at us; and I can only remember a self-conscious line of lobelias and some pitiless orange marigolds. There was a row of tall geraniums – vermilion – on the sitting-room window-ledges and between their boney stalks you could see other mountains. There was a wooden table Winifred Nicholson would have coveted outside the dairy door but we never stood flowers on that. We each took a lamp from it and carried it up to bed, although I never remember a Cumbrian summer night that ever became quite dark.

90

Everything on the farm was chucked out when my grandparents died at the end of the war — the dairy things, the great milk pans and the churns, the kist (a meal chest — another Viking word), the rag rugs, the steel fender, the rocking-chair, the settle, the feather beds. Most of it was burned in the farmyard. Some antiques went to a dealer. I suppose the bink was broken up. Soon the out-buildings were pulled down — the stables, byres and the barn where the men used to sleep in airy cubicles with their clothes on a hook behind the door. Even the old kitchen went. Nobody could live off such a little farm now, certainly not employing servants. Our farm, Thornby End, vanished like Roman Britain.

Winifred Nicholson's Banks Head survives however. I believe it is still in the family. *Flower Table* returns me to heaven.

The Deluge (1920)
by
WINIFRED KNIGHTS

The God of Genesis is a creator and destroyer who tends to see things in black and white. In Genesis VI, not long done with inventing the world, He 'looked upon the earth, and behold, it was corrupt; for all flesh had corrupted his way upon the earth … and God said unto Noah, "… Behold, I, even I, do bring a flood of waters upon the earth, to destroy all flesh, wherein is the breath of life, from under the heaven, and everything that is on earth shall die"' – excepting Noah, of course, and his chosen birds and beasts in the ark.

Winifred Knights in her 1920 picture of that event, *The Deluge*, also has her god-like qualities. I was first drawn to *The Deluge* by its striking sense of form: the bold angularities; the contrasts of light and shadow; the clear, dramatic outlines; the fan of frozen energy opening out to the right of the painting. The stylised triangular shadows there recall the abstract work of David Bomberg or Edward Wadsworth, at the Slade some half-dozen years before Knights. These shapes have their own momentum independent of the work's narrative content – upside down or on its side, *The Deluge* is still a powerful painting.

Knights is creating form, not copying it. The Collins Dictionary definition of 'form' is 'the shape or configuration of something as distinct from its colour, texture etc … the essence of something, as distinct from matter'. Knights is ruthless in what she excludes from the picture; first colour, except the range of darknesses that is grey, an earthy red and a faint luminescent green; secondly texture, for her brick and grass and water have none; thirdly detail, for the prison-like, drowning buildings and the unwelcoming ark in the background are virtually blank. She does not indulge her people either, for the ark in the middle distance to the right of the picture is already sealed, floating away, and the Bible tells us that outside it, 'All in whose nostrils was the breath of life, and all that was in the dry land, died.'

It's a big picture in scale as well as conception, measuring five feet by six feet. That Winifred Knights was only twenty-one when she painted it is astonishing; that this is one of only a handful of her pictures in public collections, and that she is virtually unknown, is a familiar kind of tragedy. Four years after Knights painted this picture she married Thomas Mon-

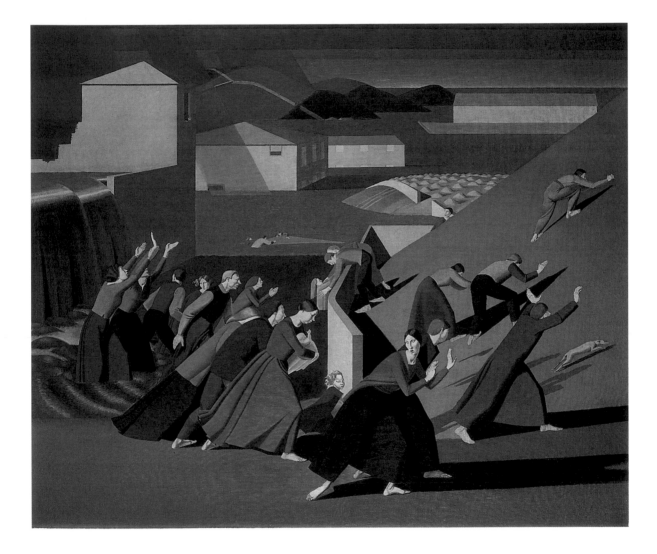

95

nington, who became a much more successful and prolific painter than her, and President of the Royal Academy. Her painting seems to have dried up, and she died aged forty-eight of a brain tumour, survived by one son and a few paintings, including this remarkable work. It is as angular and indestructible as the gravelly ashes of a body once the flesh is burnt away, and what you feel at once is the enduring energy of what was alive and the unrelenting weight of the bones.

2

The Deluge pivots on a universal myth. Story usually brings to the still space of the picture a rich potential layering, an invitation to dream and speculate, to move outside the time-frame of the picture into past and future. Winifred Knights' picture both invites and limits such speculation, keeping it within the bounds of the story's known ending and the choric discipline of her *dramatis personae*.

This is a painting of a moment, but not of the infinitely inviting and approachable Impressionist moment, where the poplars are about to sway back to the left, the little clouds to float off to the right, the man with the pipe to stop smoking and kiss the woman bringing him a beer, where life will drift lightly on into an indeterminate golden evening ...

Instead, *The Deluge* paints the arrested, frozen moment. Knight's arrow-narrow medieval hunting dog flying uphill to the right is doing just that, flying; it will never land. The dun-coloured woman mid-left whose face is obscured but whose body leans like the tower of Pisa will never move forward; her feet are pinned. The parents in the central middle distance, bending over the wall apparently to scoop up their daughter from the rising flood, are actually motionless; she hangs in the air; the father grins at her, and close inspection reveals it is a rictus, empty and terrible – they cannot save her or themselves. The beautifully long, prehensile feet of the figures in the foreground give the game away. Most of them are flat to the ground, static, theatrically posed rather than poised for flight.

The reality which will prevail lies to the back of the picture. The clouds let fall their grey weight of water, the floods rise over rooftops and hills, the ark, already closed against intruders, carries the chosen ones into their cleansed future. What we see in the foreground is really much ado

96

about nothing – brilliantly caught in Knights' people's ambivalent, aborted movements, men and women trapped in the last of the sunlight, intent on doing something, anything, actually achieving nothing. And the world around them is already barely alive; there are no animals except the unreal, heraldic dog, no birds except what is suggested in the pale 'V' made by the beseeching, wing-like hands of the two women knee-deep in water on the left, one of a series of structuring 'V's. There is no growing grass, no living grain – the piles of mown corn in the field in the middle distance are already spoiled by the rain.

This is the simplified, stylised world of myth. It is nearly all essence. These surfaces demarcate, curve, enclose and repel – but they have no texture, you can't touch them or feel them, they are impenetrable. It is a painting of paralysis, a *tableau vivant* where the players mime their helplessness, almost entirely theatrical, against a world that is flat, a stage-set.

Almost entirely theatrical, but not quite.

<p style="text-align:center">3</p>

The central 'V' of the picture is formed by the hill-slope on the right and by a line continued from the slanted rays of darkness, upper left, which are actually trailing rain – 'the same day were all the fountains of the deep broken up, and the windows of heaven were opened.' Cupped in that 'V' are all the picture's children, three in number, the eldest the girl we have already seen hanging in her father's arms. The other two are much younger. There is a baby whose shirt contains the strongest green in the picture, echoing that of the drenched field. There is also the *jolie-laide*, marvellously individual seven- or eight-year-old blonde girl in the rust-red dress, who rushes, yes actually seems to rush, forwards – we can't see her feet, but she and the baby are moving naturally, alone of all this little tribe.

The rust-red child is dead centre in the canvas, and is the only person who looks out of it, sideways, towards us, unlike all the others who look heavenwards, or up at the hill we know will soon be engulfed, or back at their homes whose walls are crumbling away, staring back into the past. She is framed by a second, echoing 'V' formed by the skirts of the older women on either side of her, shadowed by their bodies, and yet she, like the baby,

is thoroughly alive, unhypnotised by the myth of the picture. She wants to live.

And so she helps the picture to live, to be more than a metaphor with a single meaning. And for a moment it has something in common with the very different form of a novel. Though the novels I most admire do reach a final fixed point from which the book in retrospect becomes a shaped, patterned object, they are longer, looser, freer, more unruly than paintings; life creeps in and tries to be autonomous; it has to be welcomed and accommodated within the form. The novelist is not the excluding, absolute God of Genesis.

In painting, in fiction, in poetry, in film there is a constantly unravelling, shifting territory where the artist's desire for formal control meets up with the intrinsically playful, circumstantial inventiveness of her lived or dreamed material. Somewhere along that border the best art lies. The baby waves a pale green arm at his brother; the child casts her almond eyes sideways. Just possibly, the uplifted pale hands of the woman on the left suggest a dove. Three very small things have happened; their placing in the picture is still precise; the ending of the tale is probably unchanged. But the weight of the picture is shifted away from pure form. From Thanatos towards Eros, from God as death-dealer to life, for no living organism is entirely still or symmetrical; only shells and bones are pure form. And we onlookers have been made a little more welcome. *The Deluge* could never be a seductive picture, but a painted child has acknowledged us.

Catching our eye, she tempts us, this urchin in her russet dress. She tempts us to think that despite the decrees of God Almighty, against – or secretly in line with? – her female creator's intentions, she might manage to survive the flood, a little patch of red moving on its own across the featureless black waters, waiting for the loosing of the white dove.

The Window, Chiswick

(1929)

by
MARY POTTER

Many years ago I saw an exhibition of paintings by Mary Potter. They stayed in the head – delicately evocative representations of reed beds and East Anglian coastal scenes. The reed bed pictures I remember especially – all soft fawns spiced with dark touches which somehow exactly suggested a particular landscape. They seemed gratifyingly out of kilter with the current vogue for vibrant colours and exuberance. They were both allusive and precise. Much of the artistic fashion of the time seemed noisy without being particularly emotive. I remembered these paintings, though I did not see any more of Mary Potter's work until recently. I now know that the exhibition I saw must have been one of several she held at the Leicester Galleries in the 1950s.

Those muted and semi-abstract paintings are unexpected descendants of this early work, *The Window, Chiswick* painted when Mary Potter was twenty-nine and living on the banks of the Thames with her husband Stephen Potter. It is a painting of great subtlety – at the same time simple and complex, tranquil and active. We are looking out of a window; a pair of brown curtains frames the scene. The skill of the composition is the simple but marvellously effective contrast between the foreground – table, vase, flowers and book – and the scene beyond the window. Stillness as against movement; interior and exterior life. On the other side of the window is a wrought-iron gate – just suggested, scribbled in – which leads the eye up to the slice of river and the passing tug-boat. The only firm indications of movement are the frill of white at the prow of the boat and the clouds which scud in the sky above the line of houses on the far bank of the river. But it is a windy day, one somehow knows, out there. Spring, it seems to me, because the little trees daubed in beside the gate look like blossom trees. And to my mind the tug-boat is hooting. All that, proposed in a few blocks of paint.

Clear, fresh blocks of colour. In the foreground, the table is an ochre circle. On it is the book, which is peach, picking up the colour of those daubed trees outside. The flower-vase is terracotta with a creamy rim, and the two flowers are a luminous creamy-white with glowing golden stamens. They are arum lilies, a very curious choice indeed. An arum lily is not something that you pop out into the garden to pick, nor is it a usual florists' flower. How did she come by them? They are perfect, and make the focal point of the painting, but they are also faintly provocative. Do they say

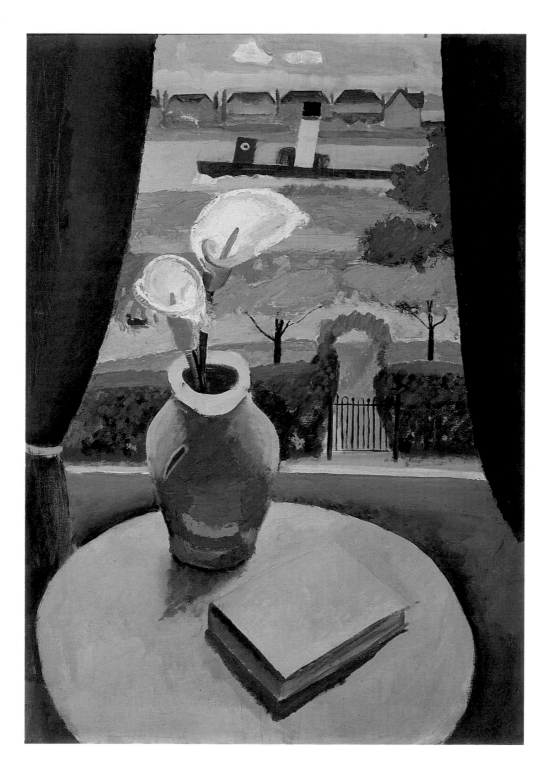

something? The arum lily is of course a funeral flower, and then there are those phallic stamens. Actually, I don't think they mean anything in particular. Somehow, Mary Potter came by a couple of arum lilies on that spring day of 1929 and saw at once that they would make the satisfying focus of a painting. And then there is the book. The book too is a touch mysterious. It is firmly closed, and its cover is quite blank. No print, no title. We are not to know what book it is. Again, I suspect there is no intended imagery. Placed thus, it is exactly right for the composition. In fact, I suspect the book had a dust-jacket on it originally and she saw that this was a distraction. The book had to be a single note of colour. Off with the dust-jacket. And the book takes on this aura of secrecy, which, like the exoticism of the arum lilies, lifts the painting on to another plane.

A successful painting is surely a marriage of accident and contrivance. Indeed I recognise an eerie affinity with the writing of fiction, in which there is of course an infinite amount of artifice and the taking of pains but in which ultimate success depends also on the happy arrival of an unexpected turn of phrase, an unanticipated twist. The arum lilies and the book are the unexpected turns of phrase, in this painting. Mary Potter probably did not know herself exactly what they were going to do, when she sat down to paint. And there is an interesting omission, too – no overt form of life. It is a picture that suggests sound and movement to me, but there is no living creature – unless the little smudge of brown to the left of the lily heads is a duck, which is uncertain. She could have put a figure on the deck of the tug, or dotted a couple of gulls into the sky. She didn't, as though testing herself, and the viewer. Let us see if it is possible to give and to receive the effect of a busy, clamorous spring day without a single sign of life. It works, to my mind.

Mary Potter was briefly a member of the Seven and Five Society, whose members included John Piper, Ivon Hitchens and Ben and Winifred Nicholson. For most of her working life, though, she seems to have been a fairly isolated figure, living and painting for the later part of her life in Aldeburgh, where she was a close friend of Benjamin Britten and Peter Pears and indeed lived out her final years in a studio built for her by Britten. Until their divorce in 1955 she was married to Stephen Potter, the author of *Gamesmanship* and other cult books of the 1950s. Success and recognition came relatively late for her. In her fifties and early sixties there was a whole

sequence of exhibitions at the Leicester Galleries, a big exhibition at the Minories in Colchester in 1961 and then a retrospective at the Whitechapel Gallery in 1964 and another at the Serpentine Gallery in 1981, the year of her death.

None of which I saw, alas. I wish I had. Somehow, I was never aware of them, and now I shall have to wait for the next. I know that her style went through many sea-changes during her painting lifetime. Her name, and a particular idiosyncratic quality of her work, have stayed in my mind for thirty years or so, since I saw that exhibition. This particular painting, *The Window, Chiswick* is not at all like the ones I saw then, but it has an affinity. It has that same capacity to share with the viewer a very precise and personal vision of the physical world. A reed bed, a snatch of the London Thames seen out of a window. Her late work is far more abstract, and acquired other strengths, but the appeal of this early painting seems to me to lie in its marriage of realism with the bold shapeliness of a certain kind of abstract painting. Here are entirely recognisable objects – the luminous arum lilies, the busy little tug, the enigmatic book – united in a composition that gives the whole scene an elegance and formality quite detached from its component parts. And the grace-note that she strikes – whether by accident or contrivance – is the emotive quality, that further dimension which makes you feel that you are there also, beside the river on a gusty April day. It is a painting which is down-to-earth – the tug, the uncompromising glimpse of a housing estate across the river – and yet allusive: the lilies, the closed book. It is this slight discordance which gives it a curious power. It ceases to be that kind of scene out of a window which has been painted a thousand times over, and becomes something memorable and arresting.

Mud Dream (1990)

by
MAGGI HAMBLING

The seven drawings of *Mud Dream* crackle and explode with energy; pulsating and swarming with life, they embody destruction and creation, moving through chaos to a final climactic moment of rebirth. The pyro-technics in the night sky, shifting and changing, form clouds, angels, cicadas, an orchestra in evening dress, the moon, a satyr; and as the marvellous evolution unfolds, the terrified eyes of the artist wait for the annihilating mud.

Mud is the stuff of nightmare, or horrible real-life catastrophe, and a dream about mud would surely be dreadful, a dream from which the sleeper would be woken by the scream which had forced itself through a desperate, constricted throat, to lie with wildly beating heart, saying, 'Thank God it was only a dream!' And yet the burden of the dream would oppress all day. The most remarkable aspect of Maggi Hambling's dream, or vision, is that she died, and she was still aware, and it is astonishing too that such a frightening dream should turn out to be an affirmation of life. The painter's own eloquent account of the drawings' genesis adds to our understanding of them and conveys the white heat of their making:

'In the early hours of 5 August 1990, I dreamt that I was lying on the ground, or in water, talking to the sky above me which was filled with exciting, changing, fast-moving "live" forms, very dark and very light. From nowhere mud appeared on the horizon and began to approach me at an increasing rate, from all sides. Gritty, wet, solid, fluid, yellowish swamping mud. I was filled with terror, but then said to myself, "It looks like this is it and I can't do anything about it." So I lay there and accepted the situation. The mud engulfed me: my body, mouth, nose and eyes. I died but the dream continued and I was still alive, in limbo.

Mud Dream was executed that morning, and the lower half of *August Night* (oil) the next day.

The concern of the previous two years' work, since my mother's death, had been the seemingly increasing speed of the passing of time and the fragile transience of life. This dream changed my attitude to death.'

Her words, and the drawings, reminded me of a dream which I had some years ago, that seemed important to me, and which will sound simplistic in the telling. Suffice it to say that mine involved a vast, benign, omnipotent golden Buddha whose message was that we need not fear death, because we become part of everything, earth, sky, water, plants, and so never really

die. Maggi Hambling's dream seems a consoling confirmation of that, something to set against the unbearable knowledge that we must part from those we love for ever, and certainly never see, hear or touch them again in the bodily forms that we loved.

Two years before *Mud Dream*, Maggi Hambling made several drawings of her mother on her deathbed. Their title, *Study From Life: My Mother Dead*, at first sight antithetical, can now be recognised as prophetic of the later dream. To draw your mother, dead, might be viewed as macabre or lacking in respect; to me it seems the right thing to have done, and the beautiful drawings, done with grace and tenderness, are worlds away in feeling, motive and execution from, say, Simone de Beauvoir's suspect and clinical blow-by-blow account of her own mother's last illness, decay and death.

Mud Dream itself, given the yellowish colour of the mud and its consistency, might have been depicted in some sludgy, sewagey impasto, but it is violently and delicately rendered in rich black Chinese ink, and cloudy grey and white spaces, splashed and dribbled with white marking fluid, scratched with a piece of bamboo, giving the sense, the flatness, of a Japanese print even as it erupts volcanically. To a writer, artists' materials are so romantic, so enviable; the names of paints and pigments and pastels so evocative and poignant; resins, clays, canvas, turpentine and oil so attractive in comparison with a bottle of Quink, blue or black, a typewriter or a word processor. There is red ink, of course, but it is difficult to read, and violet and green for decadence, but the other man's grass seems much greener; stationers' are nice but artists' colourmen's emporia are mysterious museums of delight.

Maggi Hambling's tragic view of life is seen in her paintings of tormented bulls and minotaurs; great sadness emanates from that minotaur whose head rests mask-like on his shoulders; his sexual power quiescent, he looks as if he is bewildered by this creature that is himself and wonders how he came about that long, blood-streaked hank of human meat which he trails; and in her portrait of Max Wall, the comedian's dwarfish shadow lurks behind him like Mr Hyde. Then there are her sunrises and sunsets, radiant metaphors of life and death; hers is a comic, dramatic vision too, celebrating the world and human pleasure.

Mud Dream is a distillation of many themes: essentially grand, it allows the onlooker to see stars and angels, or a burlesque show in the sky. As in the myths of winter and spring, the dying of the year and the rebirth of the

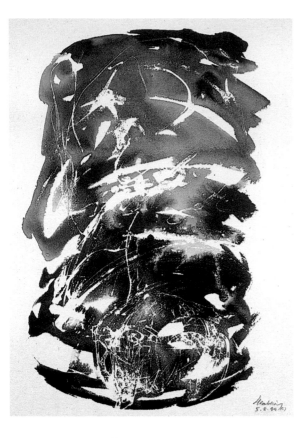

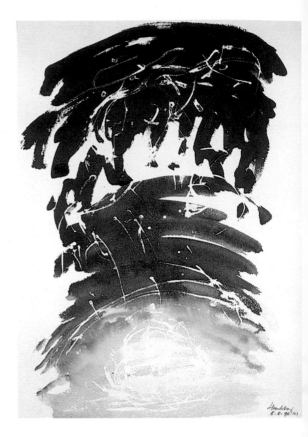

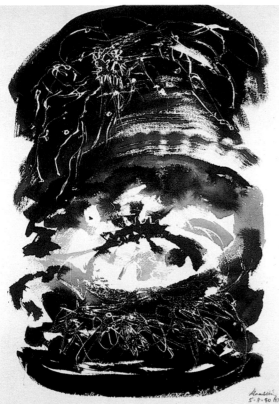

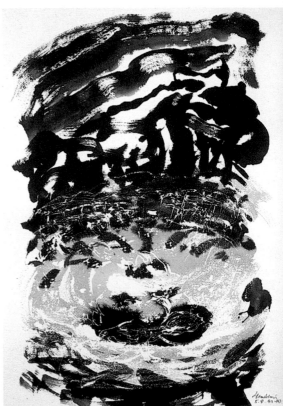

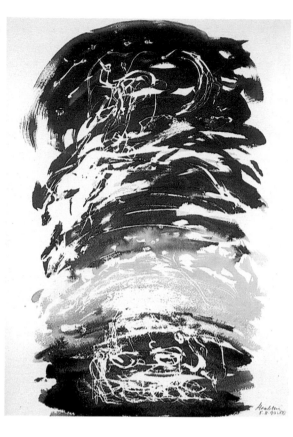

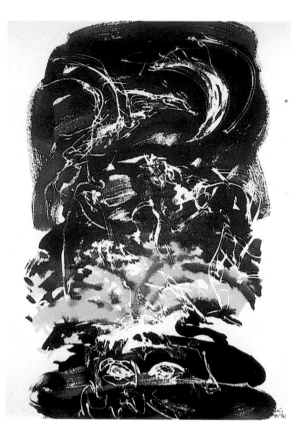

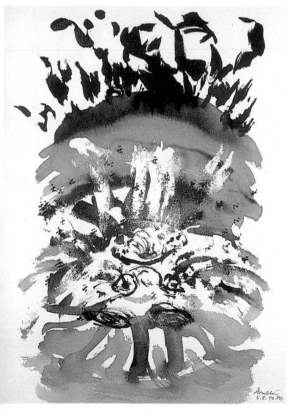

crops, death is defeated; the seven – a magical, mystical, religiously potent number – stages of the dream move through an increasingly frenzied crescendo to a triumphant climax, and life is victorious.

Loveday and Ann – Two Women with a Basket of Flowers (1915)

by
FRANCES HODGKINS

One has rolled away —
unwinding in the waves
of her private blue ocean,
knowing how right she is.
The beauty of her smugness —
Not lost on the other who sees
the pleasure of her crabbing-hand
but chooses to stay land-locked,
sulking on the sands of her own
small hurt, while flowers bear witness —
Even in the alcove of friendship
there are distances.

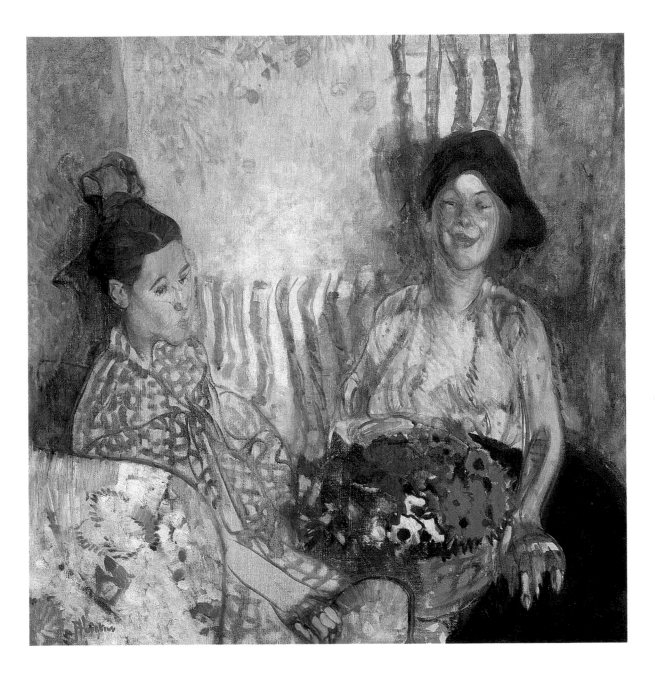

113

Michèle Roberts

The Tub (1917)

by

VANESSA BELL

The tub was made of silvery zinc, gleaming against the golden wood of the floor. It was as curved and round as her stomach. When not in use it hung from a nail in his studio. Today, because it was so hot, she'd decided to have her bath on the verandah, where the sunlight fought through the linen blinds and scorched her feet. She was going to give herself the pleasure of a bath in the afternoon. He was across the yard in his studio, working, but she was stuck. She thought she might as well take a bath. So she dropped her clothes on to the hot golden floor, then grasped the yellow curly mass of her hair and started to plait it.

He was a sculptor, and she was a writer. She wished she wasn't a writer. She didn't much like the book she was working on at the moment. It was too obvious. Too solid. It was a failure.

A sort of before-text and after-text, that's what she wished she could write. If she were cleaning up for him in his studio, which he'd never have allowed, she would like to collect up all the discarded bits which had been pared away with flicks of his knife, cherish them as equally valuable. The lost bits. You could see them as making a shape, the shape that surrounded the finished text, its echo, its mould. Yet they weren't usually considered interesting or meaningful. They were the parts that had been cut away, to give form to what their loss revealed, the shape emerging as the hand with the knife cut, cut, cut, and dropped them, gouged out, odd shapes, on to the floor, to lie among curls of woodshavings.

At the moment he was making studies of the female nude. In the mornings she modelled for him and in the afternoons she worked on her book.

She thought of the imagination as a place inside her, like an extra stomach, a geography of the interior to be mapped in darkness, then those scrawled notes to be brought out into the light, peered at, deciphered. At the moment she felt hollow and empty as the bath. So she filled the bath with jug after jug of warm water, tipped in a handful of scented amethyst salts, stirred them to make them dissolve into clouds of milk. She got into the bath and lay down. Usually she bathed with him. He'd help her wash the yellow bulk of her hair, pouring water over her head to rinse her well, his big hands moving very gently around the nape of her neck, lifting her hair, patting, holding.

She thought that if she were a sculptor she would cherish the mistakes.

116

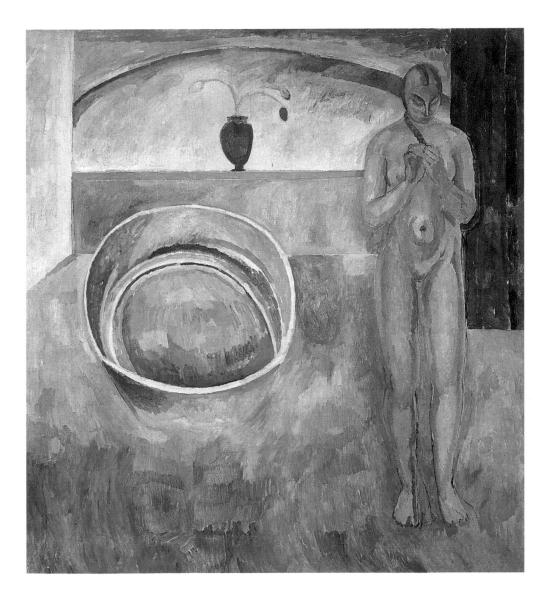

The fragments that didn't fit, that had to be thrown away for the work of art to be made, reveal itself. She thought she'd like to work with those. Pick them up, reassemble them into what might have once been their original shape, or might not, and glue them together. She'd leave the joins showing, the lines of glue, oh yes. So that you could see she'd made it up out of waste bits. She was the one who'd construct the double of the work of art, its shadow. Insubstantial. Patched up. She wanted to see them side by side. The statue. And its discarded case, mended chrysalis. She didn't know why, really. Except perhaps to show where it came from. Its origins, before it was worked on, in a block of wood. Hewn from a tree chopped down in a forest. She wanted to construct the shell of the work of art. Re-construct it. To take a handful of litter; wood chips; and re-assemble them. From an absence into a presence. What she would do with this she had no idea. Destroy it again probably. Then start afresh.

She stepped out of the bath and let the heat of the sun towel her dry. She emptied the bath. She carried jug after jug of tepid water to the edge of the verandah and flung it over the plants jostling at the garden's edge. The bath gleamed, scoured out by sunlight, silvery and golden. She loosened her hair from its tight plait pinned on top of her head, and it sprang out, a crackling mass.

Still too hot to put her clothes back on. She padded barefoot to the bedroom and put on a thin cotton kimono printed with a pattern of red and yellow flowers. She liked it because it was so old and worn that it was comfortable as her own skin. She liked the pattern, its faded colours. When it was new the red had been too bright. She'd washed it repeatedly in too-hot water to subdue it. She'd left it out in the scorching sunshine to pale a bit. Now it was just right. Very soon it would fall apart. Already it was irrecoverably torn under the arms. She poured herself a glass of red wine and sat down at her writing table. With one hand she turned over the sheets of paper in front of her on the white wood surface and with the other she absentmindedly rummaged in her yellow mane, tossed it, to turn it like meadow hay, smelling of sun, very dry.

Drops of water flew from her hair and landed on the handwritten pages of her novel. The ink puddled and swam. The words dissolved like bathsalts in the bath. They were rinsed off, streaks of blue.

She tore up these chapters she so disliked. She made a fist and let a

stream of white pieces of paper, stained with blue, flow from it.

She knelt on the floor and picked them up one by one. She laid them out on the table at random and shifted them about, as though these indecipherable torn-up bits of text were part of a collage. The word *text* gave her pleasure. A sensual word. Like *pelt*: to be stroked and caressed and made to shine. To be teased out with the fingers into a mass of loose wet connected words.

She fetched the notebooks in which she had first scribbled the notes for this stuck novel. She opened them, read and re-read, sipping her wine, sitting comfortably with one leg hooked underneath her and one foot bracing her tilted body against the floor. She tore out the pages she most enjoyed reading and strewed them on the table in front of her. She tore out the phrases and words which most appealed to her. She laid them side by side in new arrangements.

She thought of him, how at night in bed their bodies pressed together, dented one another, pushed and pulled each other into new shapes, how one underlined the other, drew the other, outlined the other, how that was always changing. She thought of their life together, how after five years they were learning to put their mark on each other, let themselves be shaped a bit by the other. They knew what it felt like inside to be the other, to use the other's muscles, and they knew how the air felt on the other's skin. Each defined themself and also the other. The dividing line was flexible, always different. They gave their bodies to each other and gave back what they received. One body, a divided body, two bodies, one body, both body. She wrote down some words.

She heard him come across the yard and up onto the verandah. She heard him start to fill the tub with jugs of water, at first a tinkling splash then a deeper one. She wiped her sweaty hands on her red and yellow kimono. She called to him that she was going to come out and share his bath, was that all right, and he shouted back yes, bring a bottle of wine and a couple of glasses.

The Corridor (1950)
by
MARIA HELENA VIEIRA
da SILVA

I hate corridors, especially tiled corridors. Also subways, lifts, mines, aeroplanes, and rooms without windows.

To call my dislike claustrophobia would be to dramatise it; it rarely stops me from going anywhere. I always get on to the aeroplane (though it's no fun for whoever comes with me) and usually into the lift. Once I did have to fight my way back up narrow steps full of tourists descending a mine, with a guide shouting after me that I could not exit in that direction. I have at times bought a tube ticket, and found myself stupidly unable to get beyond the top of the escalator, then gone to catch a bus. I couldn't make myself walk under the Thames at Greenwich.

Da Silva's picture knows this fear, and, at all sorts of levels, overcomes it. There is hope and excitement in this corridor – and best of all, relief; relief at having overcome fear, at being *en route*.

When I look at the picture, and try to work out why and how it overcomes fear, there are a number of associations it triggers which are personal. I find myself wondering very much what another viewer sees here, and how much any of it overlaps with da Silva's intentions.

Some things are clearly intended. Corridors (especially tiled corridors) are hard, cold and angular. This corridor is soft and crooked and warm, its regular shape is collapsing, and instead of repelling, it is welcoming. Tiled corridors are cold white or that bilious dark green peculiar to tiles. This corridor is pink, watery sky-blue, dun (like Shakespeare's mistress's skin), brown and flecked with white like dappled light. The restrained colours of the countryside in winter. In its chequerboard effect it is almost like a pattern of winter fields you might see from the air, spread across the undulating surface of the countryside. There is one bright salmon pink square far down on the left-hand side – something to look forward to.

The overall shape of this corridor feels like a journey. The lurching movement of ground underfoot after the entrance is fear and anxiety and making yourself do it. The wrinkling and irregularity of shapes as you move on down the corridor is the detail and ordinariness that make any frightening endeavour seem possible and normal once it is begun. The detail of the corridor continues right away to the end; what could be frightening has been broken down into a thousand fragments each of which, taken separately, is manageable. You are taken through the corridor, into the unknown, a step at a time, and so acquire a courage you did not know you had.

122

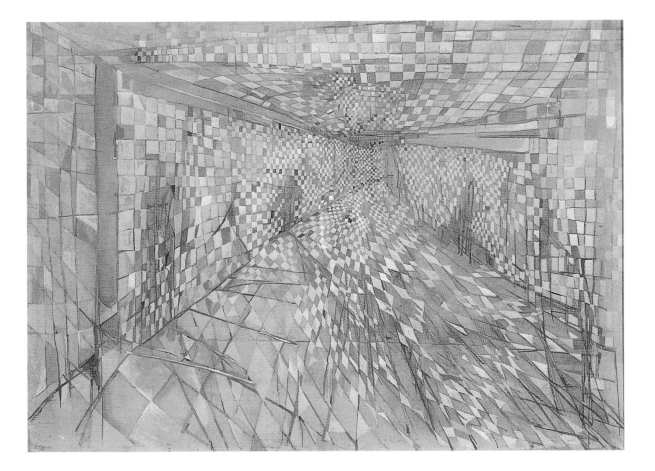

The regularity and repetition of the diamond-square shapes here seems to me to be particularly female. Traditionally, women build things thoroughly and slowly, from minutiae; they construct lives out of patient repetition, of feeding, cleaning, washing, of one day's childcare much like another. They knit, they sew. Women make beautiful patchwork quilts from domestic remnants, put together in patterns. There is something of the patchwork quilt in this corridor, right down to the way that a quilt with its regular squares or triangles or hexagons will fold and wrinkle over a sleeping body, the softness of the material beautifully countering the strict geometry of the surface pattern.

In old stories women sit at home and spin, they carry out routine and repetitive domestic tasks, day after day – while the men go off to adventures, wars and glory. Maybe this friendly crooked corridor with its irregular-regular repetitive tiles leading steadily into the unknown has something to say about that. Maybe it is laughing.

The spider's web, a regular and beautifully designed, repetitive construction, geometrical yet crooked, based on a circle – that is in this picture too. And mosaics. Fishscales. Net.

One seaside holiday when I was a child I was given a shrimping net; bamboo pole, red mesh net attached to a hoop of wire stuck into the bamboo. When I dipped it into the water I didn't catch any fish, but I caught water. Small glittering diamonds of water filled some – not all – of the mesh. When I dipped it in the water and brought it out again, the same thing happened; some of the diamond spaces between the strands of mesh were black and empty, others were coated in silver and skyblue water. It was magic, I knew that water doesn't stretch itself across gaps; water gathers in drips and falls. I remember dipping the net repeatedly and testing the pattern, the water tended to cover the same spaces each time. Even when I had had surface tension explained to me, the magic failed to evaporate. That regular pattern of net, irregularly filled with gleaming water or darkness, is stored somewhere in the depths of my memory, and one of the private pleasures of this picture is that it brings that pattern to the surface.

Corridors, of course, are journeys – with all the baggage of meanings that 'journey' carries. Leaving aside my instinctive fear of confined spaces, which is a limited (though fairly common) response; the corridor is literally a passage from one place to another, one state to another. And is very often

124

a place where hope and fear are experienced. In a hospital, you walk the corridor anxiously, knowing that when doors open there will be news of life or death. In school, the corridor is a place of banishment, you are outside the warm noisy circle of your class, and at the mercy of prowling teachers. Going to interviews and meetings, the corridor is the last place you can be yourself, nervous, incompetent, scattered, before you knock on the door and take in a persona you hope will seem convincing.

It is neither one place nor the other, the corridor; but it is the place you must go through to arrive somewhere new. And is therefore a wonderful metaphor. It may be a trial, test, rite of passage to be endured before a new phase of life can begin. It may be birth; a lurch of fear, the walls contracting and heaving around you, a strange pressure and compulsion to move, and the terror and excitement of that new, alien destination in the world outside, at the end of the living corridor. It may be death, moving through the familiar, patterned, known and knowable, limited corridor of daily life, to that vanishing point at the end – the unknown. This corridor is also rather like a fall; a vertical corridor, that you might leap or fall down, like Alice down the rabbit hole. The irregularity of the should-be-regular tile shapes can feel speedy, breathless. It may be a leap in the dark, an act of faith, a posting of yourself to an unknown destination. A declaration of love.

It is a lot of different things, this corridor, but above all it is conquering fear – not just fear of the confined space, but fear of the unknown. It says make the journey, take the step, have courage. It says, fare forward. And that's why I like it.

Joan Smith

Self-Portrait (1902)

by

GWEN JOHN

Among the Tate Gallery's collection of Pre-Raphaelite pictures is Dantë Gabriel Rossetti's *Proserpine*, executed in 1874. The model for *Proserpine*, Jane Morris, posed in side view, wearing a luminous blue gown of raw silk or silky velvet whose full sleeves drape the table next to which she stands. Her head is lowered and she stares wistfully out of the canvas, avoiding eye contact. A pomegranate is clasped in her left hand.

Rossetti's hugely popular picture is decorative, sentimental and sinister. It locates a real woman in a mythical past – several pasts, in fact, because the name Proserpine is a hybrid of two Greek and Roman goddesses while the atmosphere of the picture is cod-medieval. According to the myth, Proserpine was kidnapped by Pluto, King of the Underworld, and forced to spend half the year with him because she broke her hunger strike and ate six pomegranate seeds. But somewhere in the iconography of the painting lurks the spectre of Eve, another woman who tasted forbidden fruit, and it should come as no surprise to anyone who has studied this sensual, death-laden image that Rossetti was in love with his model and blamed her for not leaving her husband, the designer William Morris.

While Rossetti was struggling with this subject – he eventually painted it eight times – a daughter was born to a solicitor and his wife in the Welsh coastal town of Haverfordwest. As an artist she would never achieve anything like Rossetti's fame during her lifetime, yet she created a body of work which relegates Rossetti's brooding images of women to the realm of adolescent fantasy. Gwen John never painted a pining damozel in her life, although her human subjects were almost exclusively female; where Rossetti and the other Pre-Raphaelite Brothers draped women in glamour and imprisoned them in myth, John was obsessed with truth, painting the same subject over and over again until she felt she had captured its essence.

She trained at the Slade and then in Paris where she was taught by Whistler. She had to be coaxed into exhibiting her work, which she sold only to relieve her extreme poverty, and she supported herself in Paris by sitting for a variety of indifferent but demanding female painters. She also posed for Rodin, who used her as the model for his memorial to Whistler, carried on a ten-year affair with her in spite of the great difference in their ages – she was twenty-eight when they met, he sixty-three – and treated her as cavalierly as he did his other lovers.

During the final seven years of her life she lived in increasing isolation,

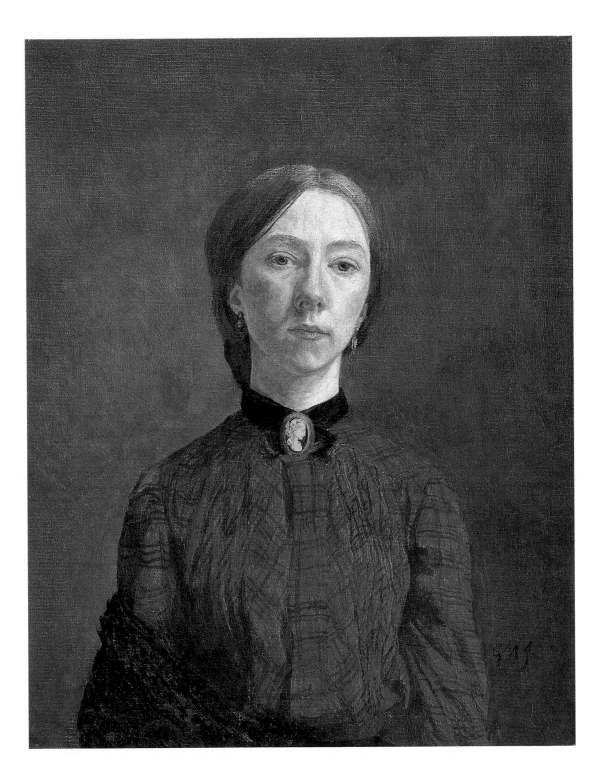

129

cultivating an ascetic existence which was in some degree a product of her conversion to Roman Catholicism and her growing mysticism. She barely ate, living on a liquid diet, an infusion of malted barley which she prepared in three-day batches. According to her friend Louise Roche, taking solid nourishment 'inconvenienced' her: Roche remarked that Gwen 'treated her body as though she were its executioner'.[1] There is a clear suggestion here of anorexic decline, no doubt aggravated by her rejection in 1932 by Véra Oumançoff, sister-in-law of the Catholic philosopher Jacques Maritain, to whom she was passionately attached. She died days after the outbreak of World War Two in September 1939, collapsing in the street in Dieppe as she tried to follow her younger brother Augustus to England. She was sixty-three, had travelled from her home in Meudon without luggage, but had arranged for someone to feed her beloved cats before setting off.

There is abundant evidence in this brief summary of Gwen John's life to suggest that her natural reticence, and the repeated rejections she experienced at the hands of people she loved, combined to undermine her sense of identity. This theme emerges again and again in her letters, notably when she wrote to Rodin that 'people are like shadows to me and I am like a shadow'.[2] Yet this uncertainty co-existed with a strong desire not to be like other people, and she was especially dissatisfied with the conventional role of a woman in love. There is a paradox here, for she was able to protest that she did not want to be like '*beaucoup des femmes – une esclave de l'homme que j'aime*'[3] while acting precisely that part in her relations with Rodin. The conflict is apparent in her art, which is full of images which explore the uncertain boundary between solitude and isolation, and celebrate the inner strength of women alone.

Her quiet domestic scenes, corners of her own rooms in Paris in the 1910s, powerfully portray the texture of her everyday life. A dress thrown over a basket-weave chair, an open window, a book lying on a table: these details vividly yet economically suggest the character of the woman who placed them there. John's interiors grow more sparsely-furnished with the years, are rendered in increasingly muted colours and in fewer brushstrokes as if she were consciously stripping down her life; there is a tranquillity about them which is not resignation but something hardier, tenacity and a devotion to truth. Gwen John was not interested in offering comfort or creating illusions, although that is not to imply that she merely produced

near-photographic images; her currency was feeling, which may go some way towards explaining why it has taken the half century since her death for her extraordinary talent to receive the recognition it deserves. Even as recently as 1971, when the American art historian Linda Nochlin wrote one of the earliest feminist essays on art history – 'Why Have There Been No Great Women Artists?' – she singularly failed to mention Gwen.[4]

Gwen John has always had admirers, starting with the American collector John Quinn who acquired much of her work and provided her with her only regular income. Augustus John, a far more flamboyant character and a celebrated artist whose reputation has now declined, remarked presciently in 1946 (I do not know in what tone of voice): 'Fifty years hence I shall be remembered only as the brother of Gwen John'.[5] Germaine Greer was an early champion, writing in her ground-breaking book *The Obstacle Race* of Gwen's 'genius' and pinpointing exactly wherein it lay: she imagined Gwen 'journeying inward, away from inherited statement to an inner truth ... to the point where all posture and surface appeal is bleached away'.[6]

It is hard to imagine a more telling description of Gwen's *Self-Portrait*, an austere and at first glance unassuming canvas acquired by the Tate in 1942. Dispensing with symbols, allegory, covert eroticism and extraneous decoration – the background is a simple, undistracting brown – the self-portrait is remarkable for its frankness. Painted between 1900 and 1903, when John was in her mid-twenties, it makes no attempt to glamorise; Gwen represented herself with her hair parted and drawn back, her face serious and slightly severe, the right cheek partly in shadow. A more frivolous side of her character is suggested by tiny gold ear-rings and the cameo brooch worn on a black ribbon round her neck, while her striking red blouse disposes of any notion that this is someone who does not wish to be noticed. Her face is slightly lop-sided, her eyes a fraction asymmetrical, and she looks directly out of the canvas, calmly insisting that the viewer engage with her. There is no coyness here, nor the pseudo-spirituality of Rossetti's women; Gwen faces the world on her own terms.

Those terms break with a long-established tradition of female self-portraiture. Women artists of varying calibre – Artemisia Gentileschi, Angelica Kaufmann, Giulia Lama, Adélaïde Labille-Guiard, and Elisabeth Vigée-Le Brun to name only a few – had chosen to paint themselves at work, emphasising their professional standing and thus precluding even a

temporary identification with the passive role of artist's model. (Models, unlike aristocratic women who could afford to pay for their portraits, were frequently working-class girls who were expected to sleep with the artists who employed them; the Pre-Raphaelite William Holman Hunt went one step further, imposing a Pygmalion fantasy on his uneducated model Annie Miller and tantalising her with unfulfilled promises of marriage.)

Gentileschi and Kaufmann played with allegory to make extravagant claims for themselves, Gentileschi using the feminine gender of the noun *la pittura* (painting) in Italian to represent herself as its personification in a voluptuous self-portrait (1630). Kaufmann painted herself 'in the Character of Painting Embraced by Poetry' (1782) and 'Hesitating Between the Arts of Music and Painting' (1791); the latter canvas is particularly boastful, its immodest suggestion of outstanding talent in two fields defused only by Kaufmann's winsome femininity.

Gwen John's *Self-Portrait* is free of such whimsy. Unlike Gentileschi and Kaufmann, who painted to commission, Gwen's art was integrated into her life. In one of her most productive periods she wrote: 'I am quite in my work now & think of nothing else. I paint till it is dark, & the days are longer now & lighter, and then I have supper and then I read about an hour and think of my painting and then I go to bed. Every day is the same. I like this life very much.'[7]

For someone as immersed as this in painting, painting chiefly for herself, external props were simply redundant. Unsure of herself in many other ways, Gwen had a small kernel of self-knowledge which told her not just that she was an artist but that her work would endure. It is characteristic of the woman in the *Self-Portrait* that she should have offered this quiet verdict on herself: 'As to me, I cannot imagine why my vision will have some value in the world – and yet I know it will ... I think I will count because I am patient and *recueillé*.'[8] These aspects of her personality, her patience and her habit of looking inward, are both superbly captured in the *Self-Portrait* but the picture is also quietly iconoclastic, substituting an uncompromised and uncompromising human being for the male fantasies about women which hang on the walls of most major galleries. In this respect Gwen John's art is truly revolutionary, overturning received opinion and confounding tradition; no wonder the blouse in the self-portrait is bright red.

1 *Gwen John* by Susan Chitty, Hodder & Stoughton 1981, p. 196.
2 *Ibid*, p. 14.
3 *Gwen John* by Cecily Langdale, Yale University Press 1987, p. 33.
4 Reprinted in *Women, Art, and Power and Other Essays* by Linda Nochlin, Thames and Hudson 1991.
5 Chitty, *op cit*, p. 16.
6 *The Obstacle Race* by Germaine Greer, Secker & Warburg 1979, p. 327.
7 Langdale, *op cit*, p. 73.
8 *Ibid*, p. 123.

Sue Townsend

The Machine Minders

(1956)

by
GHISHA KOENIG

The circumstances were not ideal for visiting the Tate. My feet were hurting, and I was carrying a huge bunch of lilies which had been presented to me at a function earlier. Their perfume was so strong that I felt drugged as I walked around the rooms. I sat down frequently to rest. The place swarmed with people; some, showing by their clothes and conversation that they were 'artistic', strode around as if they owned it. Others entered the rooms more timidly, as though wishing there were a door to knock on first.

I was thinking about leaving, of falling into the back of a black cab, when I turned into a room and saw – *The Machine Minders*. I had never seen it before, but I felt as though I had known it all my life. I remember I said, 'Oh' out loud. I walked around it, like a dog defining its territory. My feet stopped hurting and the lilies ceased to be a burden.

The Machine Minders is a sculpture showing two men, half-life-size, minding a machine. They are so alike they could be twins, but you sense that they are not; they have worked together for so many years that they now look like each other. One is taller, and one has a bigger nose. They have a repetitive job and have made the same movements millions of times. They no longer have to think about what they are doing, they are able to inhabit dreamland. They look like brutish gods, wife beaters, saints. They engender our fear, and our pity. They belong to another generation who believed that work would always be available. These machine minders have hired out their bodies. They are subordinate to the machine they watch. They have few decisions to make during their working day, and whatever fantastical thoughts inhabit their large heads, they keep to themselves.

They are unbearably sad. They are the old men in my family.

Ghisha Koenig sculpted *The Machine Minders* in 1956. What looks like stone is in fact a cement-based material. The pipe is metal and the base and the barrier in front of them seem to be made of ancient wood. They are meant to be looking down into an ink vat.

They are working to provide me with the ink to write this article. *The Machine Minders* are as full of mystery as the figures on Easter Island; their bulk implies that they will last forever. Ghisha Koenig has given us a piece of work that both celebrates and condemns our industrial past. *The Machine Minders* represents a class unused to praise, but I wanted to lay my flowers at their feet, in thanks.

136

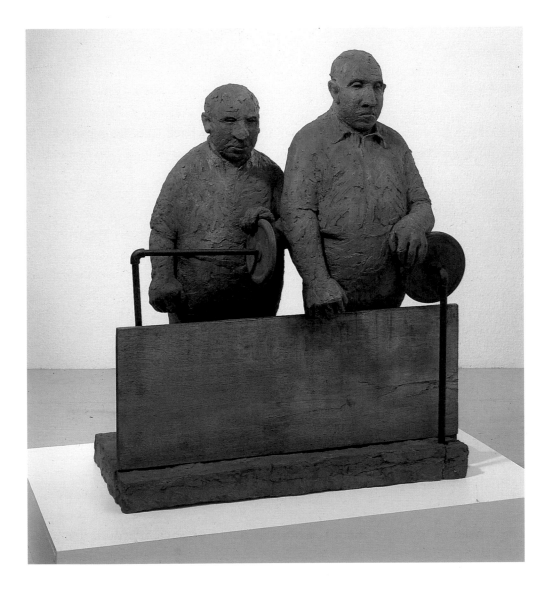

The Artists

Vanessa Bell (1879–1961) Born London, elder sister of Virginia Woolf. Married the art critic Clive Bell in 1907 and became one of the central figures of the Bloomsbury Group. First solo exhibition at Independent Gallery, London in 1922. Painted mainly in Sussex and France. Known for portraits, interiors, still lifes and designs for textiles and pottery.

Elizabeth Blackadder (b. 1931) Born Falkirk, Scotland. Studied at Edinburgh University and College of Art. First solo show at 57 Gallery, Edinburgh in 1959. First woman Academician of both the Royal Scottish Academy and the Royal Academy. Awarded OBE in 1982. Known for portraits, landscapes, still lifes and exquisite watercolours of flowers.

Elizabeth, Lady Butler (1846–1933) Born Switzerland née Thompson. Family moved to London in 1861. Studied at the Female School of Art, South Kensington and was praised by Ruskin. *The Roll Call* shown at the Royal Academy in 1874 to great acclaim. 1877 married Major William Butler.

Rita Donagh (b. 1939) Born Wednesbury, Staffordshire. Studied Fine Art at the University of Durham. First solo exhibition at Nigel Greenwood Gallery, London in 1972. Has taught art at Newcastle, Reading, the Slade School and Goldsmiths' College. Married to the artist Richard Hamilton, and exhibited with him at the ICA in 1984. Trustee of the Tate Gallery from 1977–84.

Evelyn Dunbar (1906–60) Born Reading. Studied at Rochester and Chelsea Schools of Art, and the Royal College. Painted murals in a school at Brockley and a college at Bletchley. Official War Artist 1940. Visiting tutor at Ruskin School of Art, Oxford in the 1950s. Illustrated *Gardener's Choice* with Charles Mahoney, 1937.

Sheila Fell (1931–79) Born Aspatria, Cumberland, where her ancestors had lived since the fourteenth century. Studied at Carlisle and St Martin's School of Art, London. Solo exhibitions at the Beaux Arts Gallery, London in 1955, 58, 60, 62 and 64. Won prize at John Moore's Liverpool exhibition in 1957. Elected RA 1974.

Dame Elisabeth Frink (1930–93) Born Thurlow, Suffolk. Attended Guildford and Chelsea Schools of Art. First solo show at St George's Gallery, London in 1955. First commission for public sculpture in 1957, *Blind Beggar and Dog*, for Bethnal Green; numerous commissions followed including Coventry Cathedral in 1962. Awarded DBE in 1982 and Companion of Honour in 1992.

Maggi Hambling (b. 1945) Born Suffolk. Studied with Cedric Morris and Lett Haines in Suffolk. Appointed first Artist in Residence, National Gallery, London 1980. Major exhibitions: Portraits of Max Wall at National Portrait Gallery, 1983; Serpentine Gallery, 1987; Yale Center For British Art, USA, 1991.

Dame Barbara Hepworth (1903–75) Born Wakefield, Yorkshire. Studied at Leeds College of Art and the Royal College of Art, London. Married the sculptor John Skeaping in 1924. Lived and worked in Hampstead from 1928–39, then moved to St Ives, Cornwall with her second husband, the painter Ben Nicholson, and their triplets. Retrospective exhibitions at the Whitechapel Art Gallery, London in 1952 and 1962, and the Tate Gallery in 1968. Created DBE in 1965.

Frances Hodgkins (1869–1947) Born Dunedin, New Zealand. Came to Europe in 1901. First solo exhibition at Paterson's Gallery, London in 1907. Taught watercolour at the Atelier Colarossi, Paris in 1908. Spent much time travelling, but lived from 1914–19 in Cornwall. Worked as a fabric designer in Manchester from 1923–6. Lived in Dorset from 1920s until her death. Memorial exhibition at the Tate Gallery in 1952, and major retrospective exhibition in New Zealand in 1993.

Beatrice How (1867–1932) Born Bideford, Devon. Studied with Hubert Herkomer and at the Academie Delacluse, Paris. Lived most of her life in France, although visited England every year. Worked in the Red Cross and painted village children with Red Cross nurses during the First World War. Was a friend of Renoir and Bonnard. Memorial exhibition at the New Burlington Galleries, London in 1935.

Gwen John (1876–1939) Born Haverfordwest, Wales, elder sister of Augustus John. Studied at the Slade School and at Whistler's school in Paris. Settled at Meudon in 1914. First solo exhibition at the New Chenil Galleries, London in 1926. Memorial exhibition at the Mattheisen Gallery, London in 1946 which established her reputation.

Winifred Knights (1899–1947) Born London. Studied at the Slade School, winning both the Slade Scholarship and the Rome Scholarship in Decorative Painting. Worked at the British School in Rome 1920–4, where she met her husband, the painter Thomas Monnington. Painted a triptych of St Martin for the Milner Memorial Chapel, Canterbury Cathedral in the early 1930s.

Ghisha Koenig (b. 1921) Born London. Studied at Hornsey School of Art, Chelsea School of Art under Henry Moore and then the Slade School. Member of ATS during Second World War. First solo exhibition at Grosvenor Gallery, London in 1966, more recent one at the Serpentine Gallery, London in 1986. Executed many public commissions including for the Festival of Britain in 1951, and the church of St John the Divine, Wandsworth in 1961.

Winifred Nicholson (1893–1981) Born Winifred Roberts in Oxford, granddaughter of the ninth Earl of Carlisle. Studied at the Byam Shaw School of Art, London. Married the painter Ben Nicholson in 1920. In 1924 bought Banks Head, a farmhouse built on a mile-castle on Hadrian's Wall, which remained her home until her death. First solo exhibition at the Mayor Gallery, London in 1925. Tate Gallery retrospective exhibition in 1987.

Mary Potter (1900–81) Born Mary Attenborough in Beckenham, Kent. Studied at the Slade School, winning a Slade Scholarship in 1919. First solo exhibition at the Bloomsbury Gallery, London in 1931. Married to the writer Stephen Potter from 1927–55. Lived and worked in Aldeburgh, Suffolk from 1951. In later years painted with light muted colour harmonies and trod a delicate line between figuration and abstraction.

Paula Rego (b. 1935) Born Lisbon. Attended finishing school in Kent, then the Slade School of Art. Married the painter Victor Willing (1928–88) in 1959. First solo exhibition at the Sociedade Nacional de Belas Artes, Lisbon in 1965. Retrospective exhibition at the Gulbenkian Foundation, Lisbon and the Serpentine Gallery, London. Appointed first Associate Artist of the National Gallery, London in 1990. Her mural, *Crivelli's Garden*, unveiled in brasserie of Sainsbury Wing of National Gallery in 1991, making her the only living artist in the gallery.

Maria Helena Vieira da Silva (1908–92) Born Lisbon. Moved to Paris in 1928 and studied at several art academies there, as well as with artists such as Bourdelle, Leger and Bissière. First solo exhibition at the Galerie Jeanne Bucher, Paris in 1933. Took French nationality in 1956. Awarded the Grand Prix for Painting at the Sao Paolo Bienal in 1961. Interested in exploring in her work systems of perspective and spatial ambiguities.

The Writers

Beryl Bainbridge is the author of fourteen novels, two works of non-fiction and five television plays. Her fiction includes *An Awfully Big Adventure* which was shortlisted for the 1990 Booker Prize and, most recently, *The Birthday Boys*. She lives in London.

Elspeth Barker is the author of *O, Caledonia*, a first novel which won the 1991 David Higham Prize, the Royal Society of Literature's Winifred Holtby Prize, the Scottish Arts Council Spring Book Award, the Angel Literary Award and was shortlisted for the Whitbread First Novel of the Year Award. She lives in Norfolk.

Pat Barker was selected, in 1983, as one of the Best of Young British Novelists. Her first novel, *Union Street*, was recently filmed as *Stanley & Iris*. Subsequent novels include *Blow Your House Down*, *The Century's Daughter*, *Regeneration* and, most recently, *The Eye in the Door*. She lives in Durham.

Clare Boylan is the author of four novels and two collections of short stories. Her most recent novel, *Home Rule*, is a prequel to her much-praised first novel, *Holy Pictures*. Her most recent publication is *The Agony and the Ego*, a collection of essays on the art and strategy of fiction writing, which she edited. She lives in Wicklow.

Eleanor Bron is an actress and writer. As well as work for television she has written two volumes of autobiography, *Life and Other Punctures* and *The Pillow Book of Eleanor Bron*. She has recently translated *Desdemona, If You Had Only Spoken* by Christina Brückner and her one-woman show based on speeches from it was a hit of the 1992 Edinburgh Festival.

Katie Campbell's first book was a collection of stories, *What He Really Wants is a Dog*. She has also written a novel, *Live in the Flesh*, a volume of poetry, *Let Us Leave Them Believing*, and various plays for stage and radio. She lives in London.

Wendy Cope's publications include two bestselling collections of poetry, *Making Cocoa for Kingsley Amis* and *Serious Concerns*. She lives in London.

Maureen Duffy is a poet, playwright, biographer, social historian and novelist. Her fiction includes *That's How It Was* and, most recently, *Occam's Razor*. She is a past president of the Writers Guild and current chair of the British Copyright Council. She lives in London.

Elaine Feinstein is a poet, the translator of *The Selected Poems of Marina Tsvetayeva* and author of eleven novels including *The Border* and, most recently, *Loving Brecht*. She was made a Fellow of the Royal Society of Literature in 1980 and won the Cholmondley Award for Poetry in 1990. She lives in London.

Eva Figes is a novelist but has also written four non-fiction books including the influential *Patriarchal Attitudes*. Her second novel, *Winter Journey*, won the *Guardian* Fiction Prize. Other works of fiction include *Nelly's Version*, *The Seven Ages* and, most recently, *The Tenancy*. She lives in London.

Margaret Forster is a novelist, biographer and critic. She is the author of sixteen novels and five works of non-fiction, including *Elizabeth Barrett Browning* which won the 1988 Royal Society of Literature Award and, most recently, a biography of Daphne du Maurier. She lives in London and Loweswater.

Jane Gardam is the author of nine works of fiction, including *God on the Rocks* which was shortlisted for the 1978 Booker Prize and, most recently, *Queen of the Tambourine* which won the 1991 Whitbread Best Novel award. She lives in Kent.

Maggie Gee was selected, in 1983, as one of the Best of Young British Novelists. She has written six novels, including *The Burning Book*, *Light Years*, *Grace* and, most recently, *Where are the Snows*. *Lost Children* will be published in 1994. She lives in London.

Penelope Lively is a novelist and short story writer. She has also written many books for children. Three of her novels have been shortlisted for the Booker Prize, which she won with *Moon Tiger* in 1987. Her most recent novel is *Cleopatra's Sister*. She lives in Oxfordshire and London.

Shena Mackay has written eleven works of fiction including *Dreams of Dead Women's Handbags*, *Redhill Rococo*, which won the 1987 Fawcett Prize, and *Dunedin*, which was shortlisted for the 1992 McVitie's Scottish Writer of the Year Prize, the *Guardian* Fiction Prize and awarded a Scottish Arts Council Bursary. Her latest work is a collection of stories, *The Laughing Academy*. She lives in London.

Grace Nichols writes poetry and fiction for children and adults. Her first volume of adult poems, *i is a long memoried woman*, won the 1983 Commonwealth Poetry Prize. Her first adult novel, *Whole of a Morning Sky*, was published in 1986. She lives in Sussex.

Michèle Roberts is a writer of poetry, short stories and novels. Her fiction includes *A Piece of the Night*, *The Wild Girl* and most recently *Daughters of the House* which was shortlisted for the Booker Prize and won the W. H. Smith Award. She lives in London.

Jane Rogers is a novelist whose books include *Her Living Image* – winner of the Somerset Maugham Award – *The Ice is Singing* and most recently *Mr Wroe's Virgins* which she adapted into a successful television series. She lives in Lancashire.

Joan Smith is an essayist and novelist. She is the author of two non-fiction books, *Clouds of Deceit* and *Misogynies*, and four crime novels, two of which, *A Masculine Ending* and *Don't Leave Me This Way*, have been adapted for television. Her most recent novel is *What Men Say*. She lives in Oxfordshire.

Sue Townsend is the author of the bestselling *The Secret Diary of Adrian Mole Aged 13¾*, *The Growing Pains of Adrian Mole*, *Rebuilding Coventry*, the plays *Bazzar & Rummage* and *Groping for Words*, and most recently, *The Queen & I*. She lives in Leicester.

An Introduction to Coping with
Anxiety

2nd Edition

Brenda Hogan
and
Lee Brosan

ROBINSON

ROBINSON

First published in Great Britain in 2018 by Robinson

3 5 7 9 10 8 6 4 2

Copyright © Brenda Hogan and Lee Brosan, 2018

The moral rights of the authors have been asserted.

A CIP catalogue record for this book
is available from the British Library.

Important note
This book is not intended as a substitute for medical advice
or treatment. Any person with a condition requiring medical
attention should consult a qualified medical practitioner
or suitable therapist.

ISBN: 978-1-47214-024-1

Typeset in Bembo by Initial Typesetting Services, Edinburgh
Printed and bound in Great Britain by CPI Group (UK) Ltd,
Croydon CR0 4YY.

Papers used by Robinson are from well-managed forests
and other responsible sources.

Robinson
An imprint of
Little, Brown Book Group
Carmelite House
50 Victoria Embankment
London EC4Y 0DZ

An Hachette UK Company
www.hachette.co.uk
www.littlebrown.co.uk
www.overcoming.co.uk